THE
LIVING
RIVER

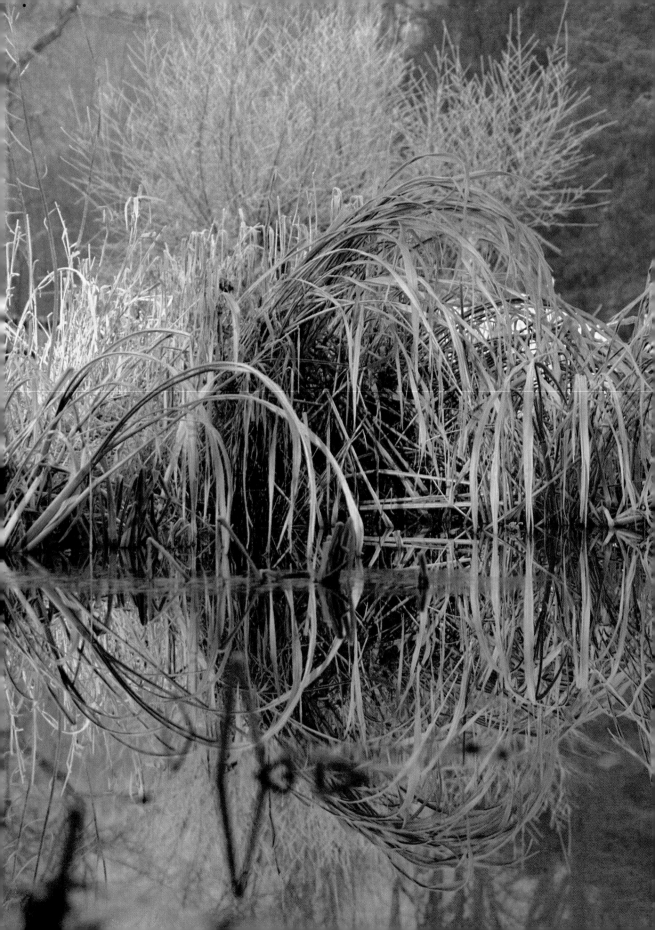

THE LIVING RIVER

A Photographic Journey

DAVID BOAG

BLANDFORD

To Janet

Blandford
An imprint of Cassell
Villiers House, 41/47 Strand,
London WC2N 5JE

First published 1990

Distributed in the United States by
Sterling Publishing Co. Inc.
387 Park Avenue South, New York,
NY 10016-8810

Distributed in Australia by
Capricorn Link (Australia) Pty Ltd.
PO Box 665, Lane Cove, NSW 2066

British Library Cataloguing in Publication Data

Boag, David
 The living river.
 1. Rivers
 I. Title
 551.483

ISBN 0-7137-2123-5

Typeset by Litho Link Limited,
Welshpool, Powys

Printed and bound in Portugal
by Resopal

CONTENTS

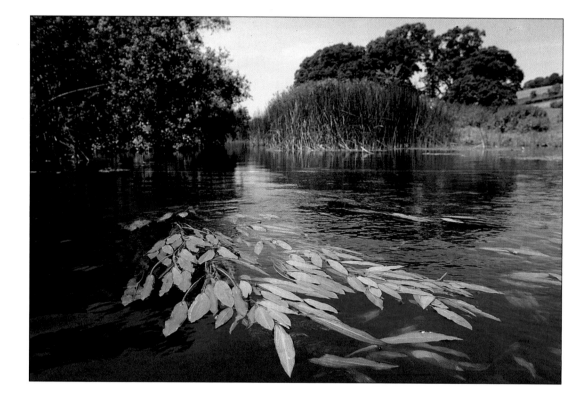

PREFACE

MY GREATEST WISH, as you turn the pages of this book, is that you catch a glimpse of the excitement and diversity of the river. I have not even attempted to make a complete record of a river, for it defeats human ability for one man, in one year, to capture the entire life of the river in one book. The variety of habitat, the diversity of plants, the multitude of insects and the hosts of fish, birds and mammals make it impossible, even in a lifetime and dozens of books. In addition, erosion, plant growth and the succeeding seasons create constant change in each small part. Each creature that is associated with the river has its own life cycle; feeding, courting, breeding, dying, sometimes in the water and sometimes out. Many of these subjects are dealt with in detail, in volumes given over to a more scientific study.

I have not followed one specific river, but rather a collection of several waterways. I have not attempted to define locations because no subjects that are included are limited to one area only, and to limit the reader's view in this way defeats the purpose of this book. In the pages that follow I hope I have created a general impression of the exciting and beautiful place we loosely call 'the river'. As you turn the pages, perhaps you will sense that there is so much more to be enjoyed, and will set aside this book to go in search of 'The Living River'.

Many rivers that I followed whilst photographing the subjects for this book ran through private land and I would like to take this opportunity to thank the landowners who so willingly permitted me access to their property. I would also like to thank the many friends that have shown such an interest throughout the project. Nikon UK Ltd have been helpful with equipment, and my gratitude also goes to Ernest Charles & Co. Ltd, who partly sponsor my work. An extra thank you is due to my wife, Janet, and son, Paul, whose enthusiasm and encouragement are so special to me.

<div align="right">D.B.</div>

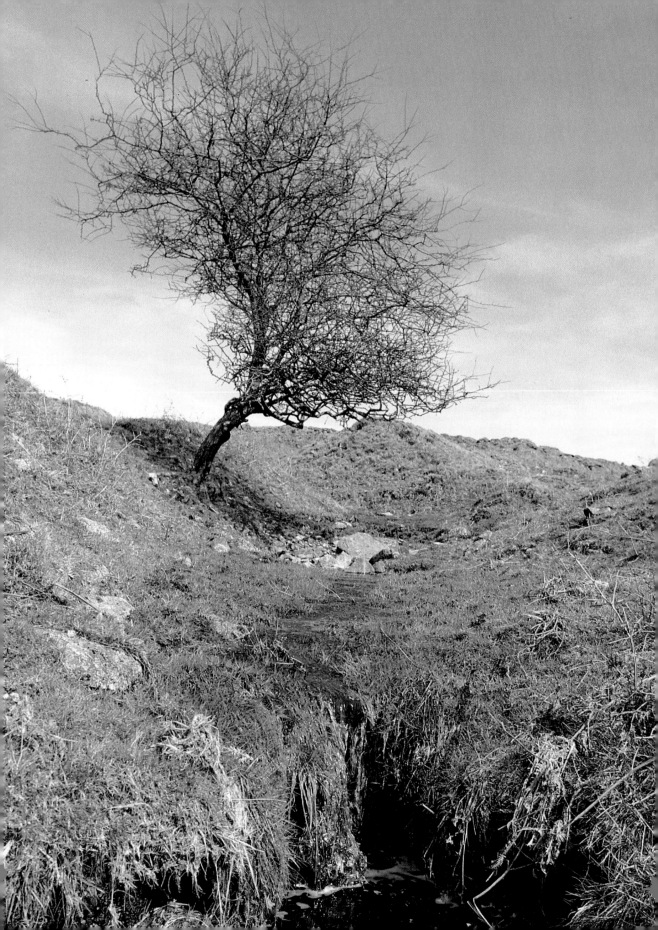

THE
SOURCE

TO ALL OF US the sight of fresh, sweet water is commonplace, and rivers and streams are a part of the natural environment that we take for granted. It is regrettable, however, that many people have become indifferent to one of nature's most beautiful, exciting and productive creations. Indeed, the river pours life into the countryside, carves out the landscape, and provides us with an appreciation of the life that surrounds us.

As children, many of us may have stared in wonder at the slowly moving mass of water, or trickled fingers into a bubbling stream. Perhaps we paddled in the shallows or clambered from boulder to boulder as we attempted to dam its path. It was then that we began to learn about the life of the river: its power, its feel, its wildlife. Perhaps in these pages we can rekindle some of the wonder and enthusiasm that we had as children.

The life of a river has been compared to the life of man, beginning its days as a babe-in-arms, unable to support its own existence, dependant on a regular supply of rain from above, or on drawing its needs from the saturated sponge of a moorland bog, or underlying rock. It lies still, softly held by vegetation. At first its existence may not even be apparent, until gentle pressure on the bog mosses brings water oozing out, and the birth of the river is revealed.

Many rivers are born in the heights of moorland or mountains, a seemingly hostile environment where the earth meets the clouds, and moisture-laden mists swirl in the constant wind. In winter the moor may be covered in snow for weeks at a time, and the stream's miniature waterfalls develop spear-like icicles; whilst in summer, heather and gorse provide a colourful back-drop.

The tiny beginnings of the river, concealed by the surrounding vegetation, may not be apparent at first as it trickles and falters along its route, but eventually it emerges into the open. Full of youth, the little brook tumbles down from the moor, its own new life bringing further life wherever it travels.

One stride of a man can cross this tiny stream, and it is difficult to imagine that it may travel hundreds of miles and grow so broad and deep that large ships can sail on it. And along its way, it will support a huge variety of wildlife.

Page 9 The peaty soil of the high moorland acts like a giant sponge, soaking up water until it overflows. Plants suited to the acid soil thrive in this environment: heather, bracken, coarse grasses, and stunted, wind-swept trees that include hawthorn and rowan (or mountain ash). Having drained down into the gullies, the water gathers in little pools that then spill over, and the river begins its journey to the ocean.

In the late summer months the moor is painted with the purple haze of heather (or ling), and green fonds of bracken give way to tints of autumn. The beauty of the moor is reflected in the still pools of crystal-clear water.

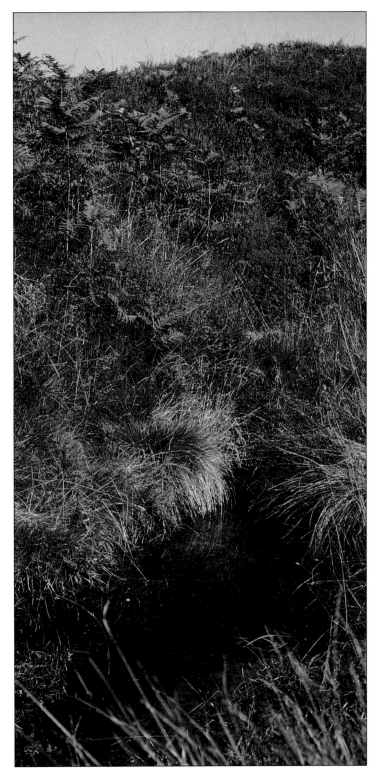

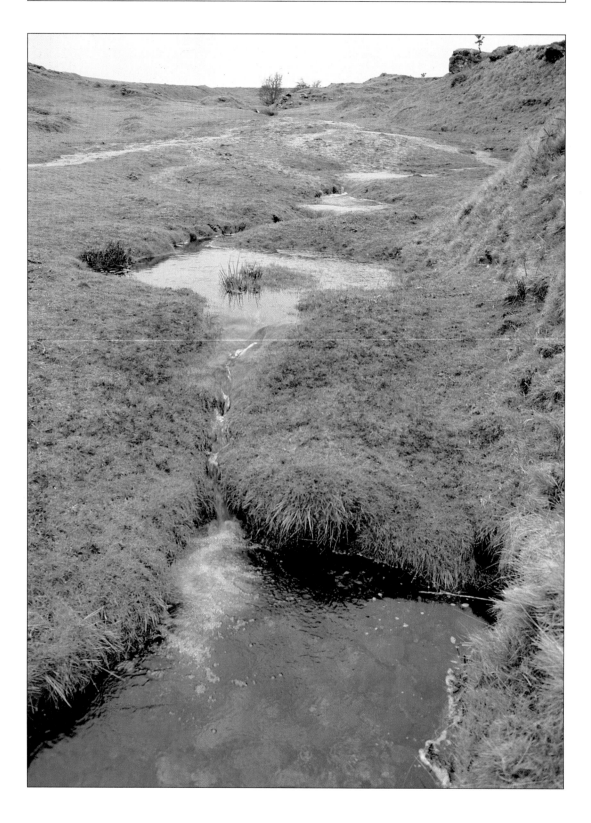

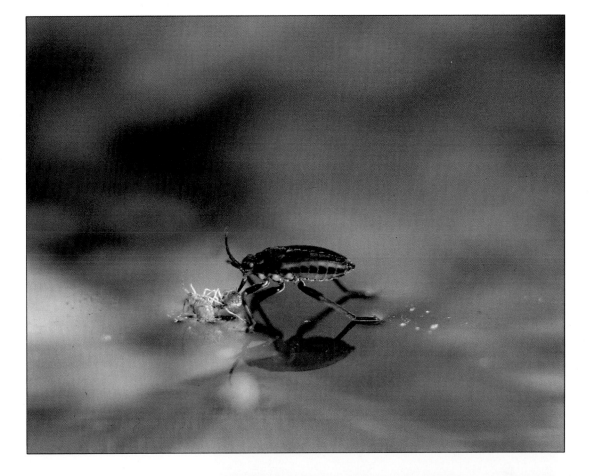

In a still pool, a tiny predator (*above*) hunts on the surface. Only a little larger than the head of a matchstick, a water-cricket scampers over the surface film to catch and devour any small creatures that fall onto the water. In some of the larger pools dozens of these wingless insects may be found.

Pondweed and mosses crowd together in the boggy areas at the source of the river. Trapped within the spongy mass of vegetation, the plants hold back the water that is their source of life, whilst within the cluttered mass of leaves, diminutive insects find a refuge.

13

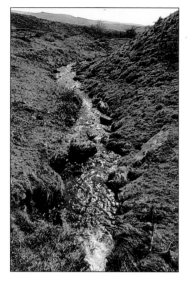

On the tops of the moors (*left*), in areas of poor drainage that are close to the river's source, fluffy white heads of cotton-grass (or hare's tail) dance in the constant breeze (*below*). The fruiting heads are made up of a mass of silken threads, each attached to a seed that will be distributed by the wind during May and June.

Typical of the moor and other acid wetlands, the spiky, yellow flower-heads of bog asphodel bring an unexpected splash of colour to the source of the river.

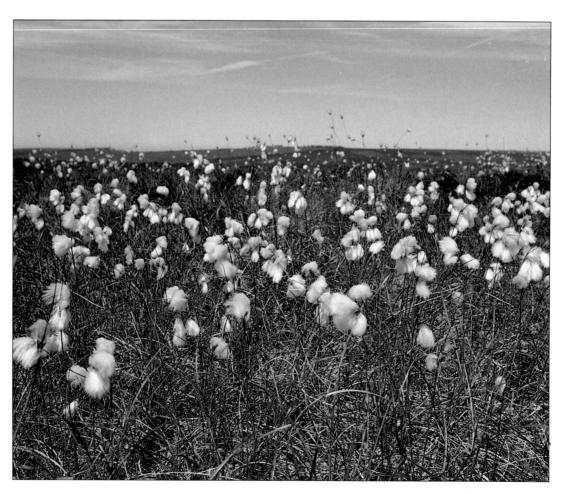

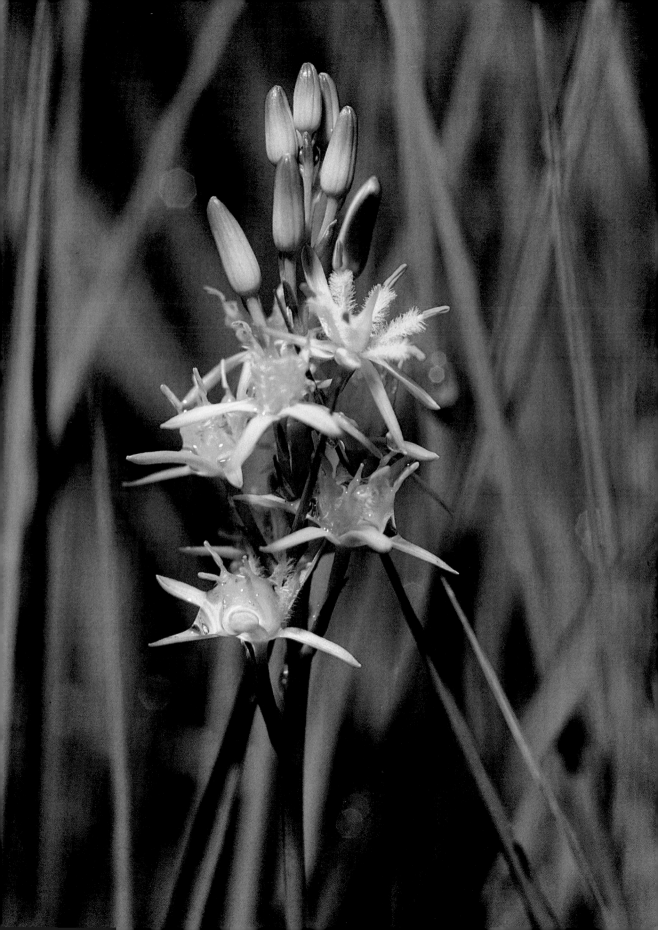

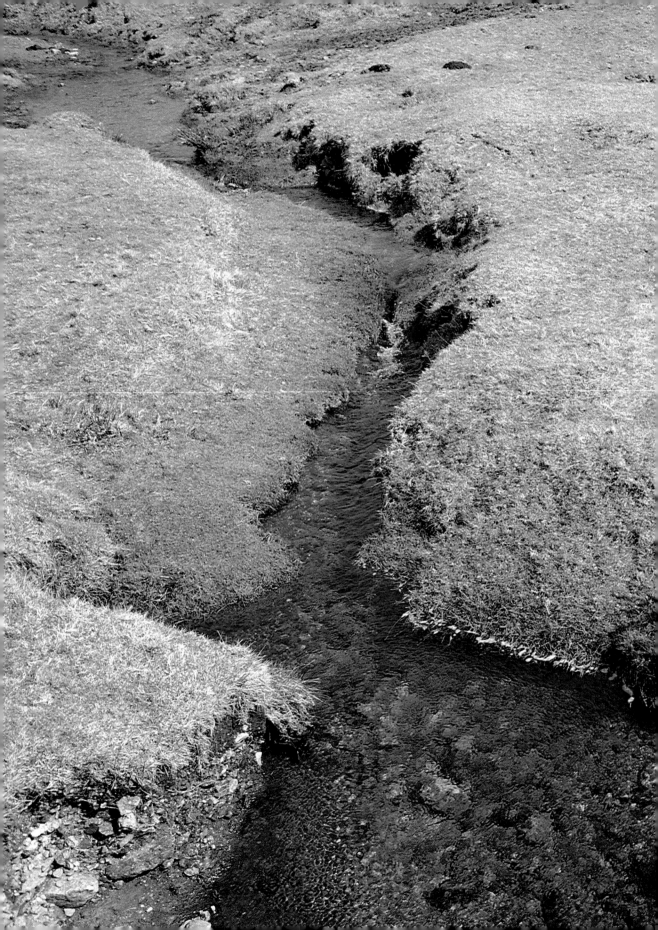

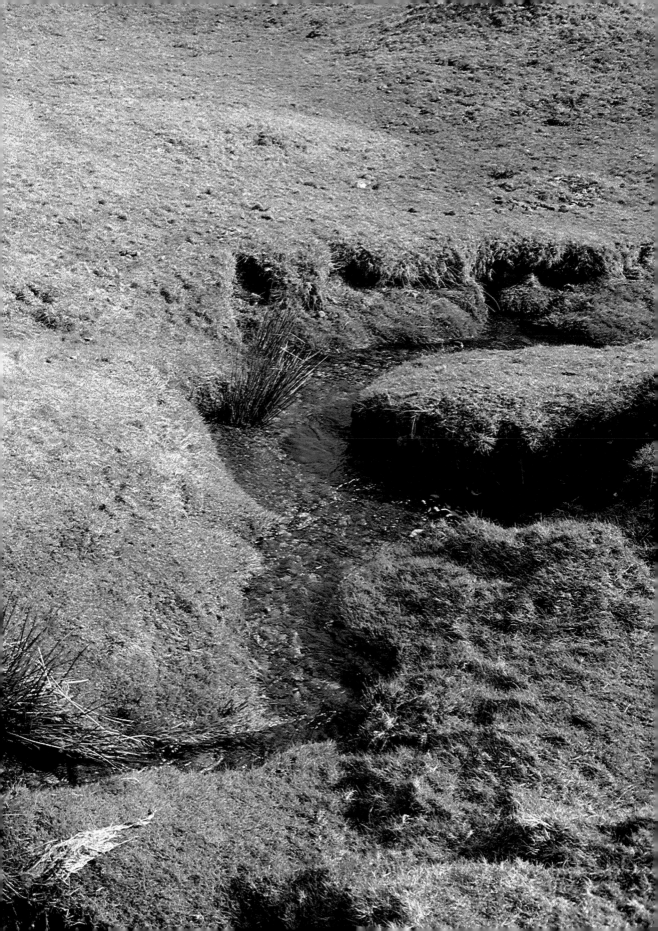

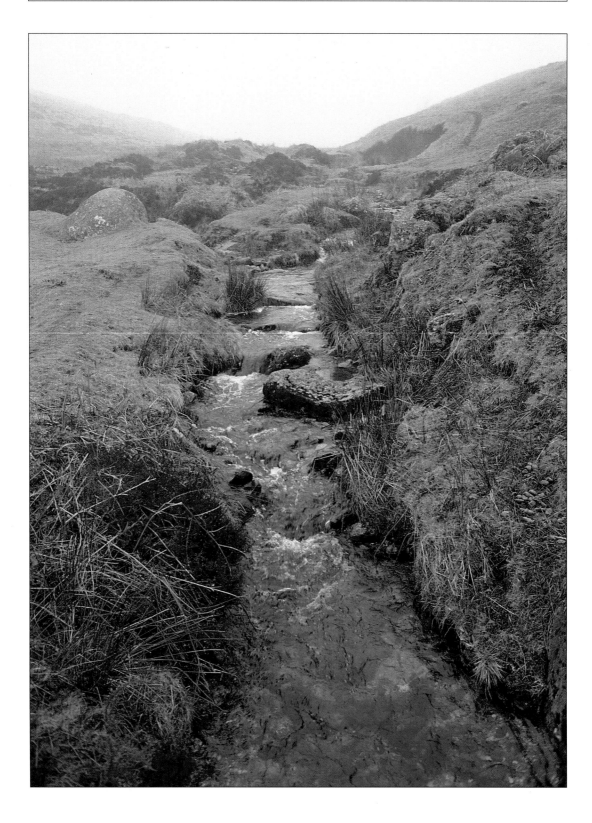

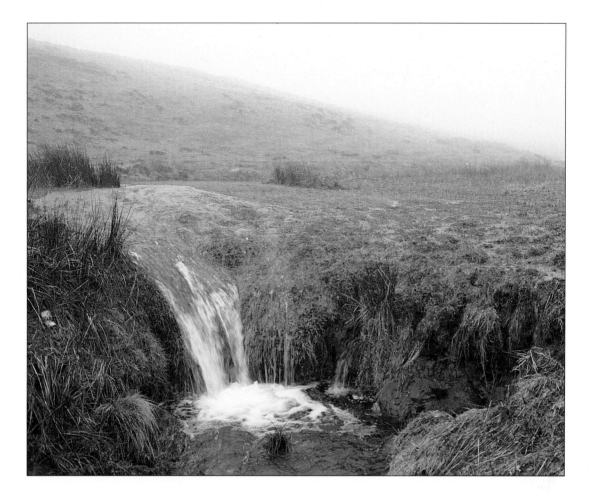

Thick swirling mists are a symbol of
the uplands, and the water contained
within the blanket of cloud, con-
tributes to the life of the newly-born
river. The little tumbling brook now
cuts its own course through the peaty
soil, sometimes spilling over before
continuing on its downward route.
When the mist hangs heavily over the
moor, the colour is drained from
every twig and stem, and life appears
to stand still in the eerie silence.

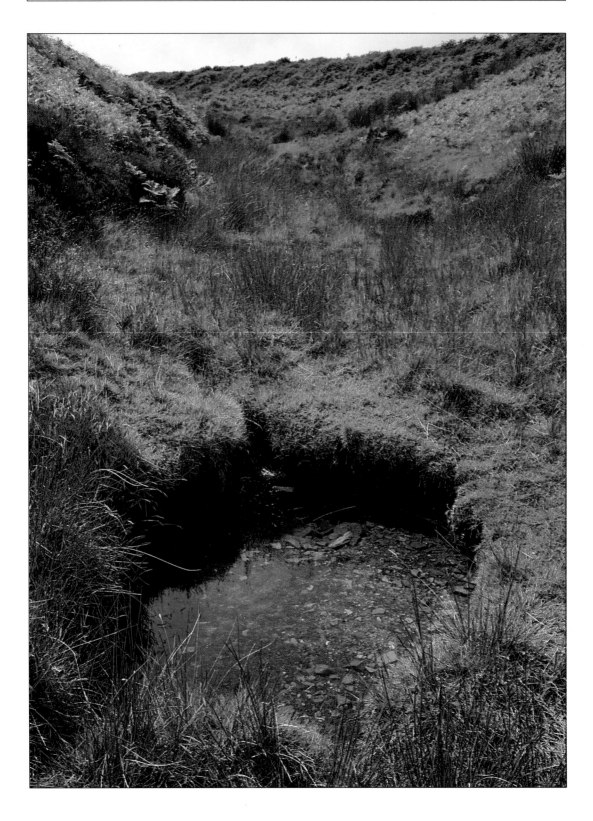

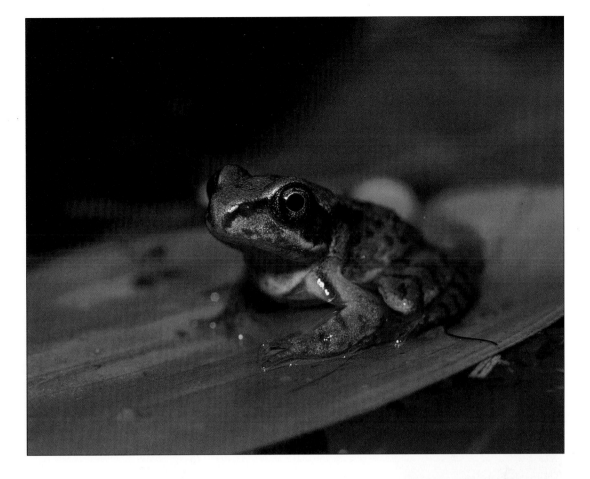

The tiny stream makes its way over the soft ground, cutting deep into the turf. The surrounding vegetation closes in over it and the only indication that water is present is the lush plant growth, and the sound of trickling water somewhere beneath one's feet. Where the passage of the water is obstructed, a little pond (*opposite*) forms in the peat; a useful drinking-place for the sheep or wild deer that roam the moorland. These miniature ponds attract a variety of wild creatures, mainly insects but also frogs that spawn in the icy water.

One of the first moorland animals to begin its breeding season is the common frog (*right*). As early as March, or even February, the sound of their calls can be heard, and pairs of frogs can be observed, locked together in the courtship embrace. The fertilized spawn is laid in frothy clumps in the cold water, and the thousands of little tadpoles that hatch feed on the algae within the water. Many changes take place within the tadpole over the weeks that follow: gill plumes appear first, and are soon followed by the legs. Eventually the gills are replaced with lungs and the tail disappears. The froglets are ready to leave the water around May or June (*above*).

Although not exclusively associated with the river, foxgloves enjoy the moisture it provides. The foxglove is one of the best known and most popular of British wild plants, but it is also extremely poisonous. Enjoying the acid soil of the moor, the tall flowering spikes have found shelter from the constant wind within the folds of the moorlands.

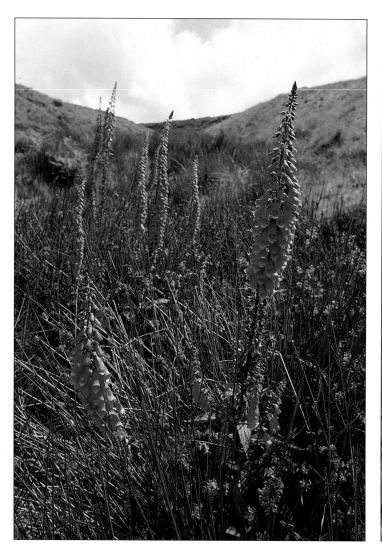

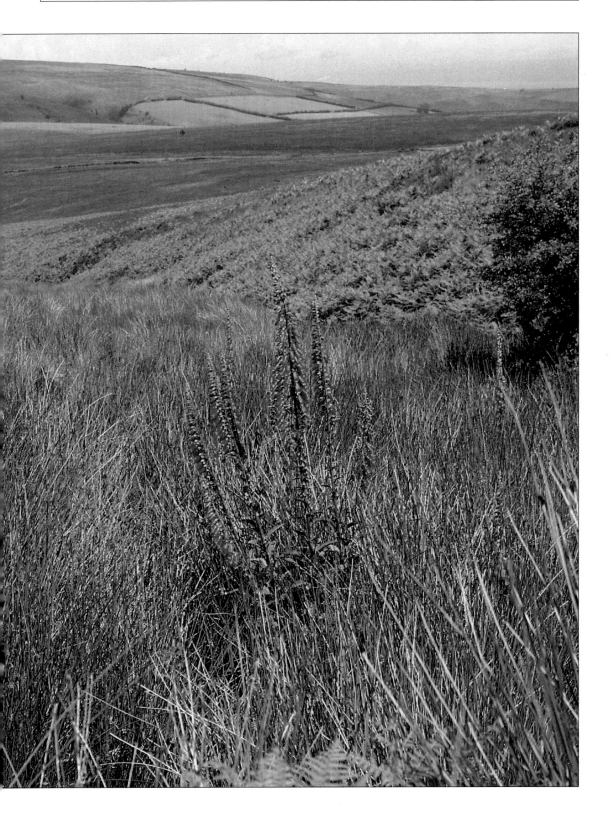

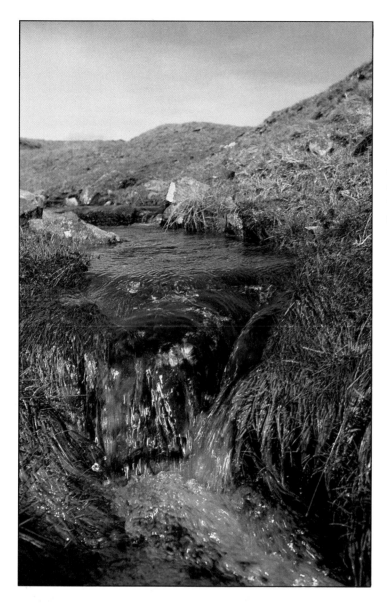

One of the most common damselflies to be found in the British Isles is the large red damselfly (*right*). It is not only found on the heights of the moors, but throughout the length of the river. It is one of the earliest damselflies to emerge from the water and can be observed in flight from May to August. During that time it will lay its eggs into the pools of the moorland stream (*left*), and the larval stage of the insect's life develops beneath the surface, where it is an active predator.

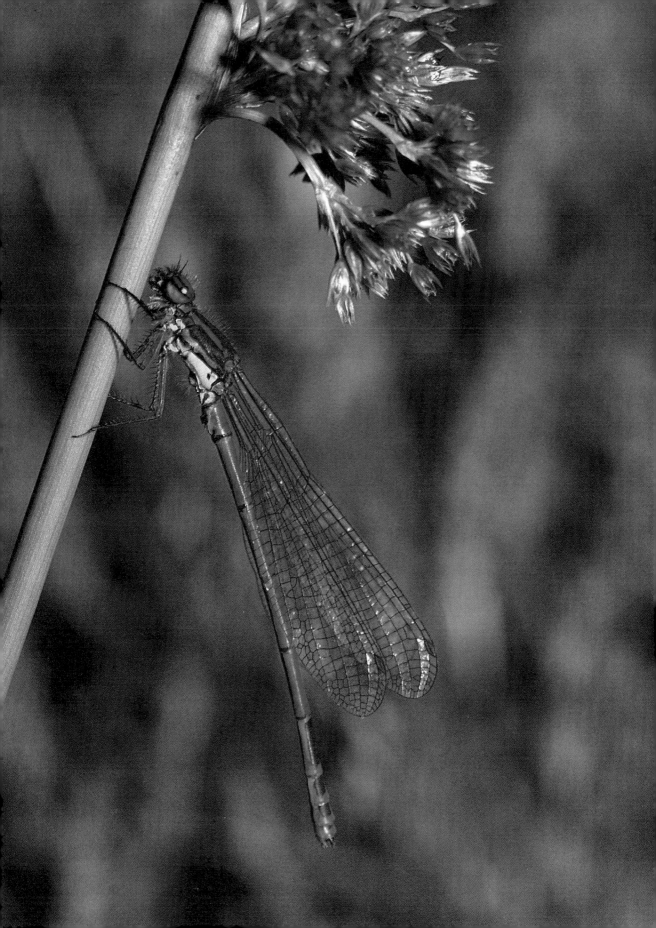

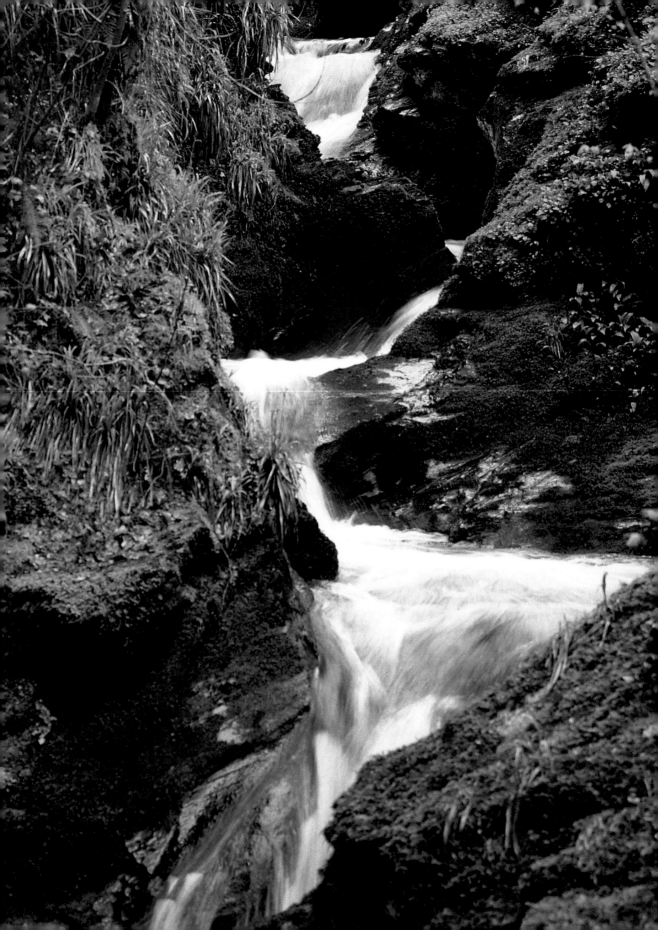

TUMBLING WATER

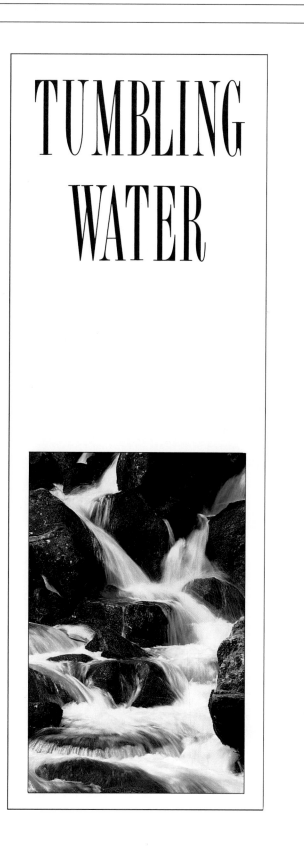

GATHERING IMPETUS , the stream tumbles down off the moor and enters its next stage of development. In adolescence it becomes boisterous, uncontrollable and noisy, bouncing from boulder to boulder as it forces its way downhill. If it cannot sweep an obstacle aside, it crashes straight past it, sweeping a great deal of debris and sediment along with it. Often it will divide, only to rejoin itself again a little further downhill, as it tries every possible route to reach its target. Its abrasive character cuts deep into the earth, in places gouging deep gullies and running directly over bedrock. Waterfalls are common, with white water spraying over the rounded black boulders. The water itself is clear as crystal, full of oxygen; but as it travels at break-neck speed it seems impossible that anything could live in it.

Any form of life that is to survive within this rushing, turbulent water has to be well adapted to its power or it could not survive. Many insects spin silken threads to anchor themselves to the river-bed; others build stones into a protective case that has sufficient weight to prevent them being swept away. Suckers, adhesive, claws, all are used to defeat the current and exploit the supply of food that is being swept down stream. Fish that travel these waters have to be powerful and streamlined, such as trout and salmon. Nevertheless there are sheltered areas even within an apparent torrent of water; crevices amongst the boulders and deep pools provide a more gentle environment for many creatures and plants.

These are delightful sections of the river to explore, boulders providing convenient stepping-stones; and the constant rush of sound is comfortable and strangely relaxing. An upland river is often flanked by woodland or grazing pasture that is pleasing to the eye, the hilly nature of the area not being suited to more intensive farming methods, and the soil being rather peaty.

Gathering nutritious sediment, the river continues down hill, although the gradient may not be as steep now; and it is several paces wide as the lowland stretches come into view.

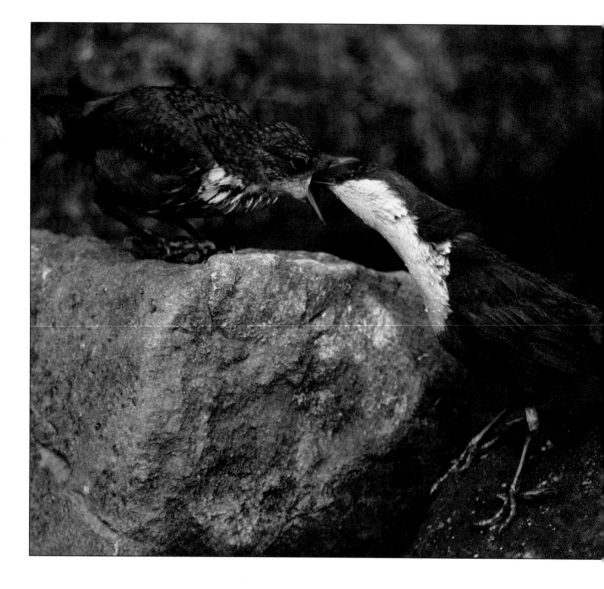

Now that the heights of the moors have been left behind, the river gathers speed and power. Crashing over boulders and rocks it tumbles downwards. Ripping the smaller stones from the bed, it leaves them in drifts on the banks. Within this stony soil the large cuckoo pint (*page 29*) has established itself. The extraordinary 'flower' resembles the more common lords and ladies, to which it is closely related. It is fertilized by a multitude of insects that are attracted to its strange scent, and in the autumn it produces a spike of bright red, poisonous berries.

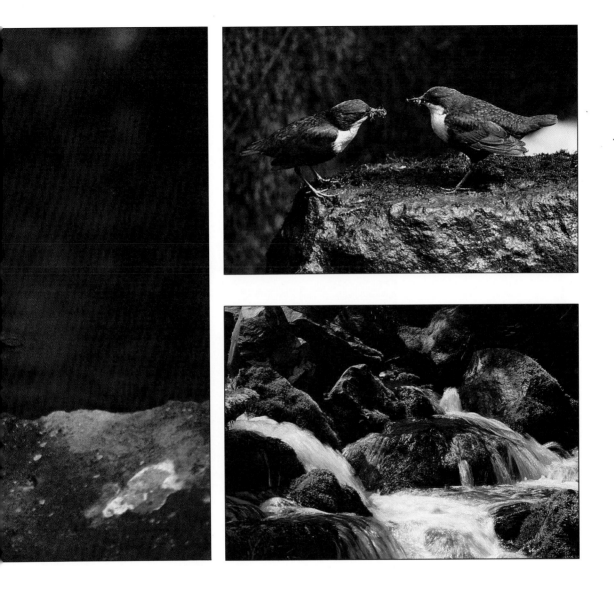

The bird that probably most typifies the tumbling water is the dipper. It is able to dive into the centre of a rushing torrent of water, swim and claw its way to the river bed, capture an insect that is clinging to a boulder, and return to the surface, without a drop of water penetrating its plumage. It even chooses to nest close to waterfalls, often in a cavity behind the falling sheet of water. When the young leave the nest they have no fear of the noisy torrent, and although they are fed by their parents for a few weeks, it is not long before they are equally at home in the tumbling foam.

Wall pennywort (or navelwort) manages to grow on a moss-covered boulder beside the turbulent water. Plunging and foaming, the river continues on its way, flanked by woodland and pastures.

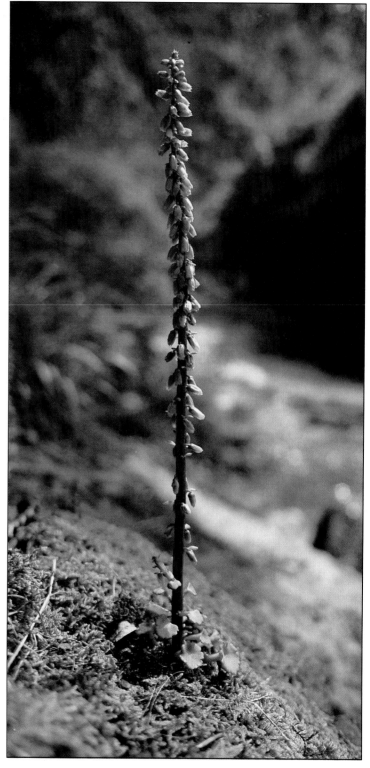

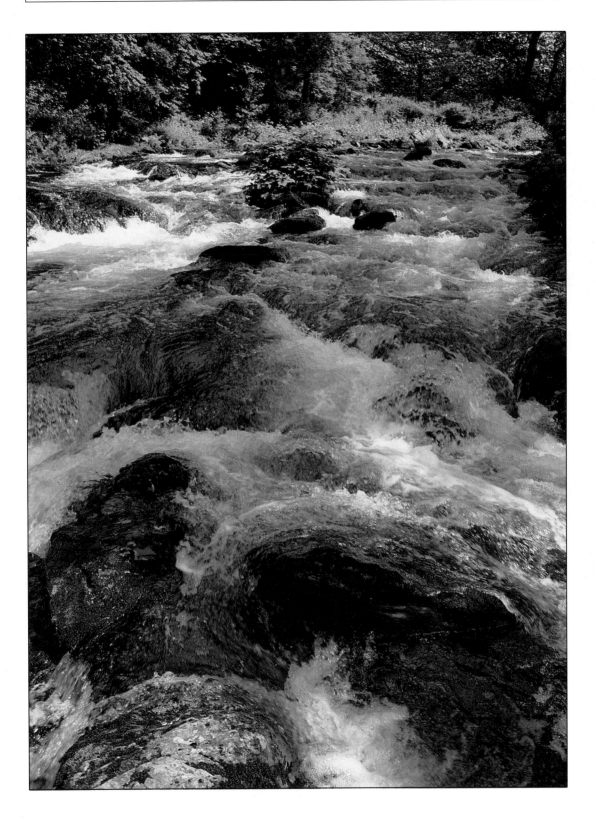

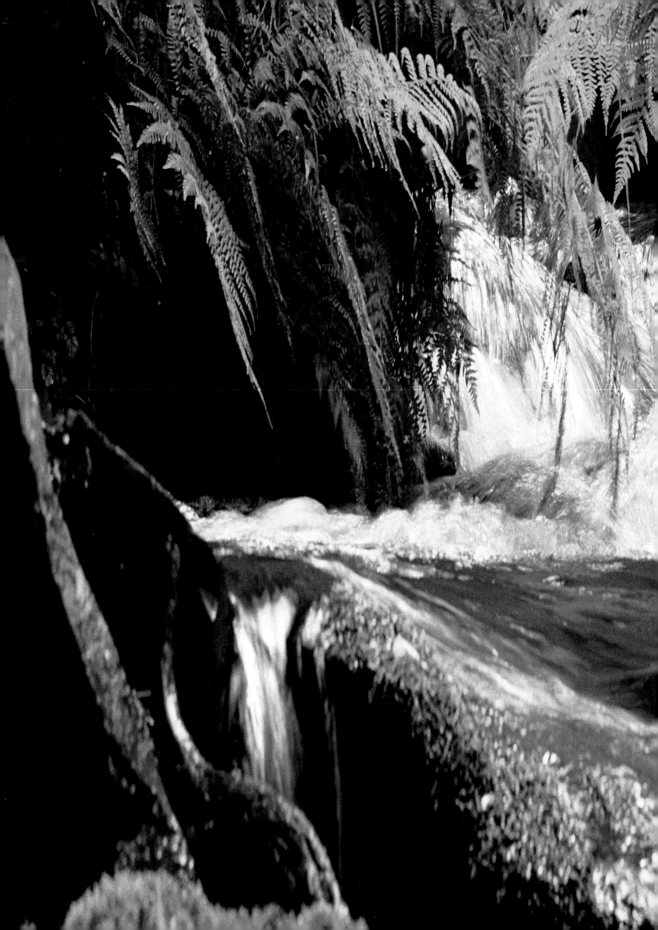

The tumbling water provides a refreshing drink for the goldfinch. It has been feeding on the seeds of a thistle that is growing on the bank, and these seeds contain little moisture. Like the goldfinch, many wild creatures drink at the river and feed among the prolific growth encouraged by the water. Although not true water or river creatures themselves, they make use of the river's bounty.

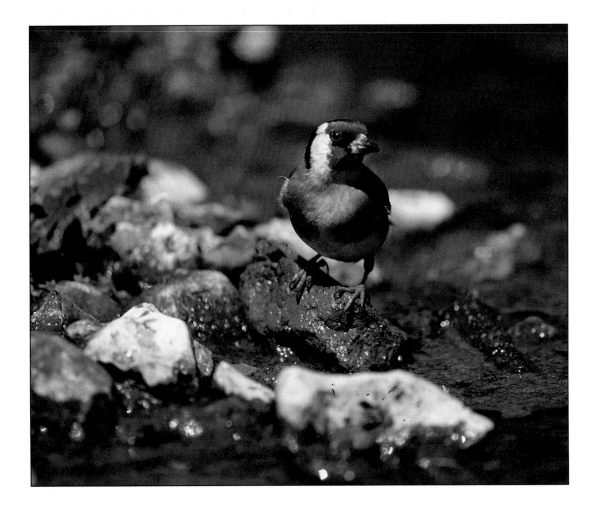

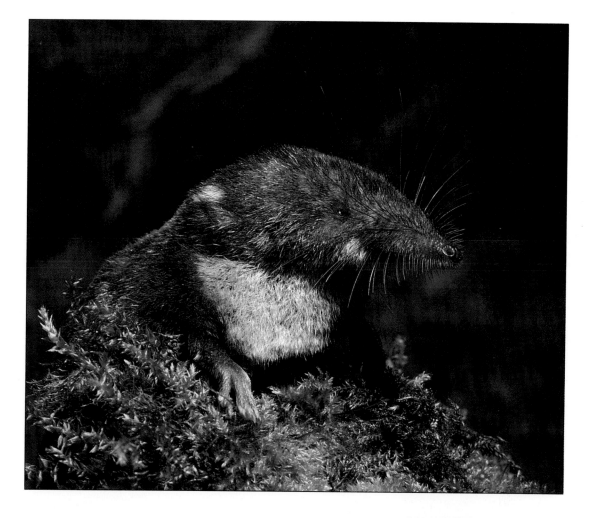

Equally at home in the water or on dry land, the water-shrew scampers amongst the boulders in search of a meal. The shrew seems to be constantly eating, and has an amazing appetite for such a diminutive mammal. In fact, it is the largest of the shrews to be found in the British Isles. On the surface or beneath the water, it is able to swim with incredible speed and agility. Its dense fur with its coarse outer hairs keep the little creature quite dry whilst in the water. Its tiny eyes give it only limited sight, and being active during both day and night, it uses its sensitive nose to smell and feel its prey.

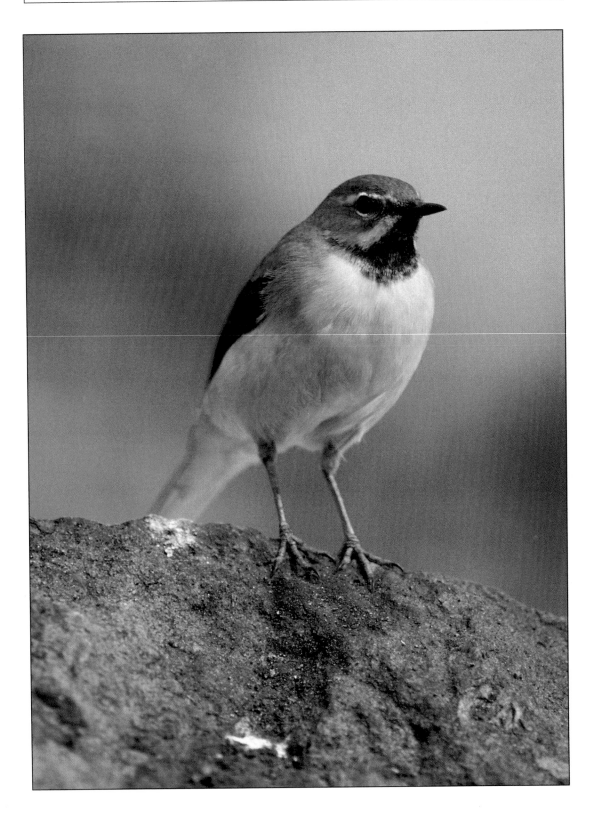

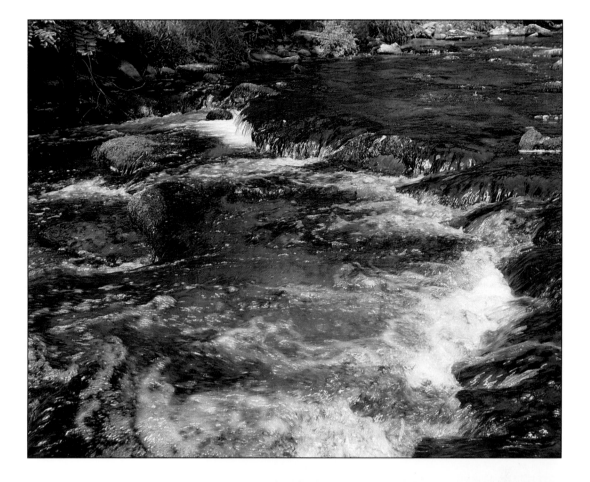

Wherever the river wanders, the grey wagtail will not be far away. Although this bird seems to enjoy the more tumbling water, it can be found along the whole of the river's length. It has learned to exploit the prolific insect-life of the river to the full. Hopping from boulder to boulder, paddling in the shallows or flitting low across the water, the grey wagtail catches insects in every imaginable way.

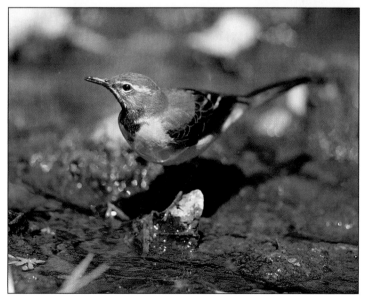

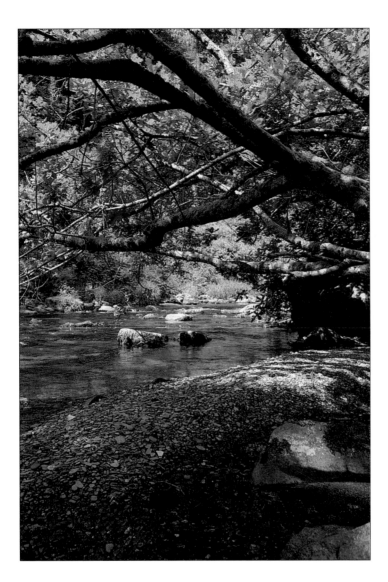

Where the river rushed and tumbled, and during periods when it was in spate, large amounts of small stones and debris were swept downstream, along with valuable nutrients. As the main force of the water subsides, much of the larger debris is deposited in banks of stone and gravel. Most of the nutritious sediment, however, remains in suspension in the water until the river slows right down and wanders through the lowlands.

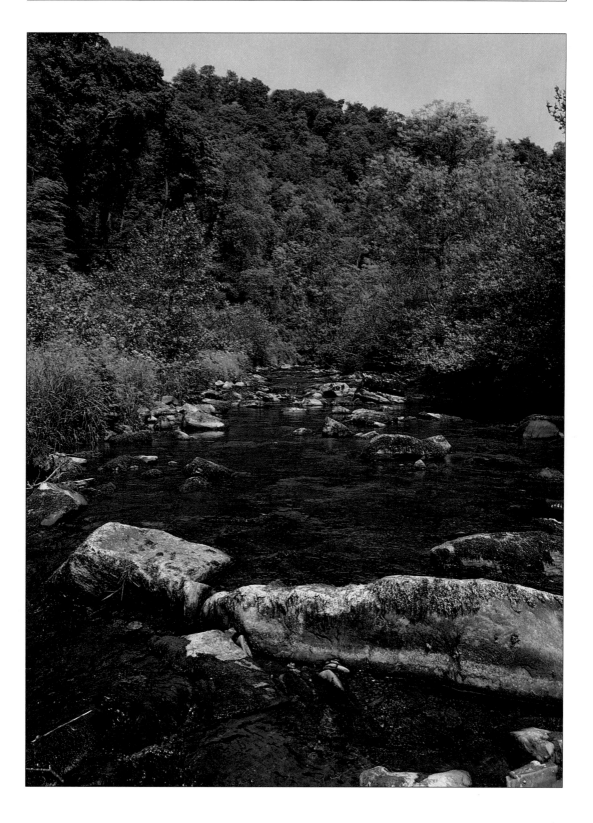

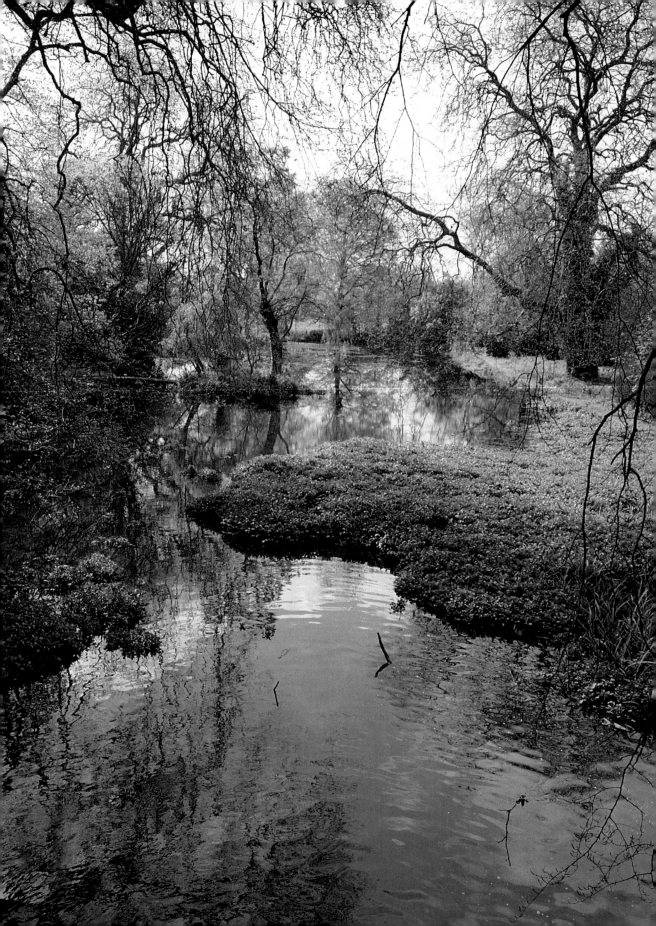

POND AND STREAM

A RIVER RARELY derives from one source as, throughout its length, smaller tributaries join it in its journey. In the past, man has found these smaller lowland reaches of river to be more easily controllable and as a result lakes and ponds have been formed; either for their aesthetic value or in order to harness the power of the water. Whatever the reason, wildlife has not been slow to make use of these diversions in the river's course.

It is in areas of still water that plants can easily become established and life can thrive with little fear of being swept away. In the stillness of the pond, the temperature of the water rises in the heat of the sun but, compared to the tumbling brook, little oxygen is absorbed from the atmosphere. Nature has solved this problem in a variety of ways. Warm, still water suits a large variety of underwater plants that enjoy the sunlight filtering through the shallows. In their underwater world, the plants produce oxygen as a by-product of photosynthesis and it is shed into the water in minute bubbles. As still water is lower in oxygen than moving stretches, many creatures breathe oxygen directly at the surface. Newts, toads and frogs, rise to the surface to gulp down air before retreating to the depths, whilst many insects pierce the surface in a variety of ways to breathe air. The water spider has a method all its own; pinching a bubble of air from the surface, it heaves it down using its legs, to a prepared platform of silk. The bubble is released beneath the platform and, along with other bubbles, forms a diving-bell from which the spider can hunt.

Most natural ponds are completely self-contained. However, ponds created by man tend to be supplied with fresh water from the stream from which they were formed, and they also have an outlet. Within this still environment the sediment that has been carried downstream, settles to the bottom, and water-plants flourish because it is fertile. Slowly the pond begins to fill in, and in time even trees, such as alder and willow, take foothold. The plants act as a trap to even more sediment, and eventually the pond turns into boggy woodland, before finally drying out completely. It would be fair to say that without the intervention of man, the delightful and rich environment of the pond would slowly disappear.

Page 43 Seeds of many plants are swept downstream, and a little brooklime plant has managed to establish itself in the shallows by using a small stone as an anchor.

A hawthorn bush overhanging the stream drops its white blossom, like confetti, onto the water. Beneath the surface, water-crowfoot has a firm rooting in the bed of the stream and its flowing fronds have trapped the falling blossom. Later in the year, the water-crowfoot will produce its own white flowers on stalks held out of the water, but today it is decorated with the petals from another plant.

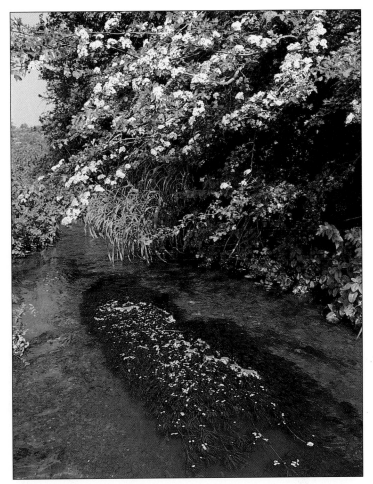

The bullhead (or miller's thumb) is so called because of its unusual shape; it has an outsized head when compared to its body. Spending much of its time in hollows fashioned out beneath boulders and rocks, it is protected from the pull of the current. Feeding on a variety of live prey, the bullhead will even ambush other small fish as they pass its hidden refuge.

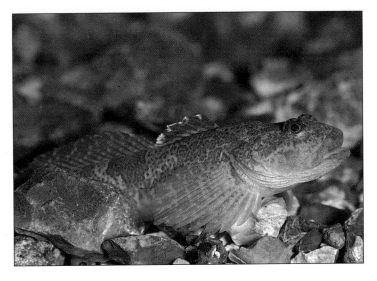

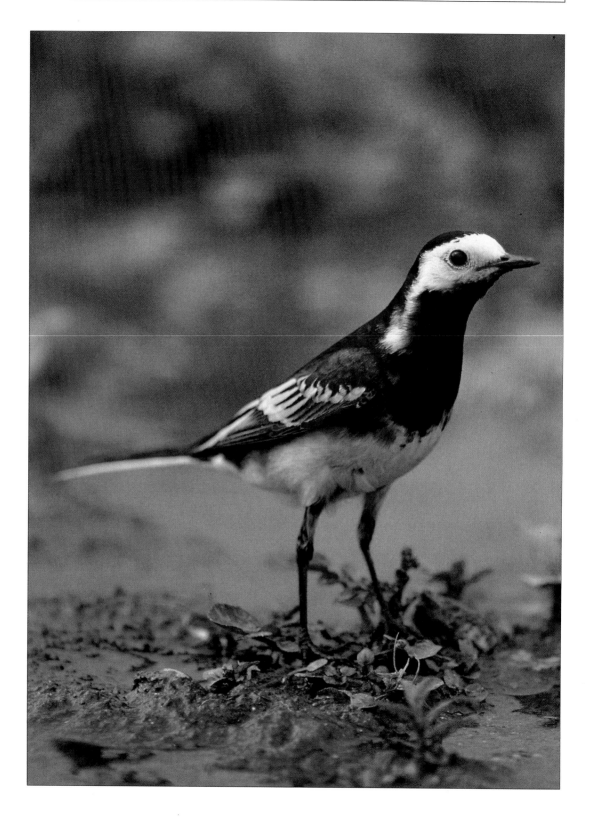

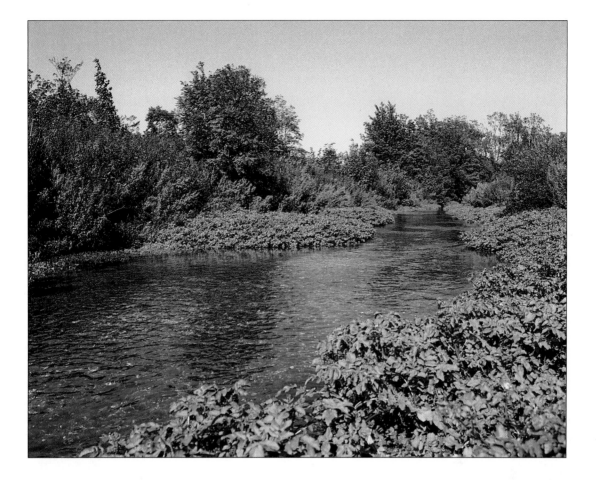

Although the pied wagtail has also been called the 'water wagtail', it is by no means exclusively a bird of the river. It is elegant and dainty as it runs through the shallows in short bursts, wagging its tail up and down. Not only does the pied wagtail gather insects from the shallows and surrounding vegetation, it also leaps into the air, twisting, turning and hovering to catch insects in flight.

The clean, shallow water and silted gravel bed suit the watercress plant, and it encroaches on the river from both sides. However, the flow of the river cannot be stopped and the more it encroaches, the faster the current will flow in the centre, preventing the watercress from becoming established right across the stream.

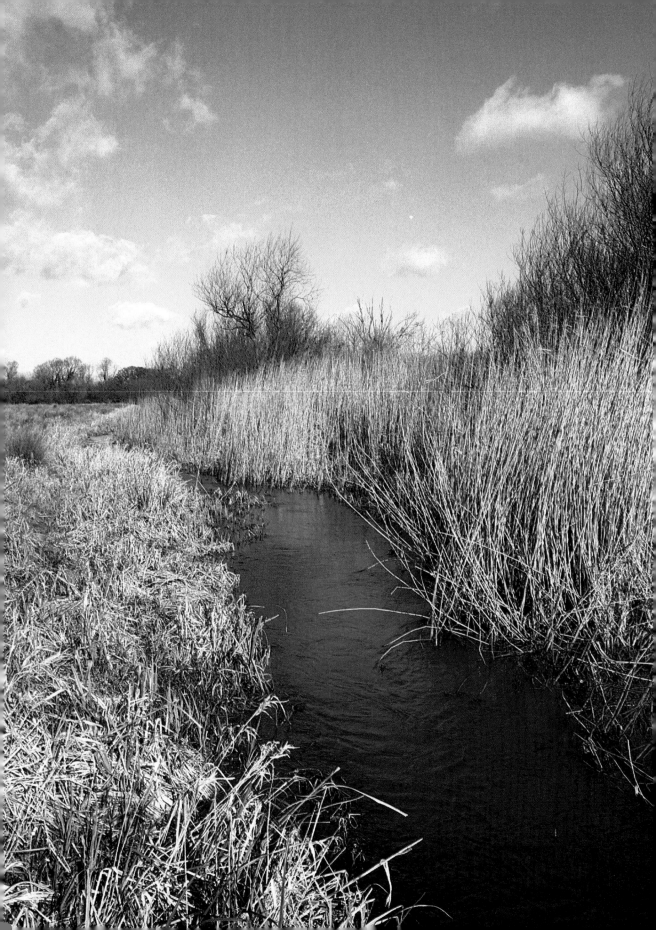

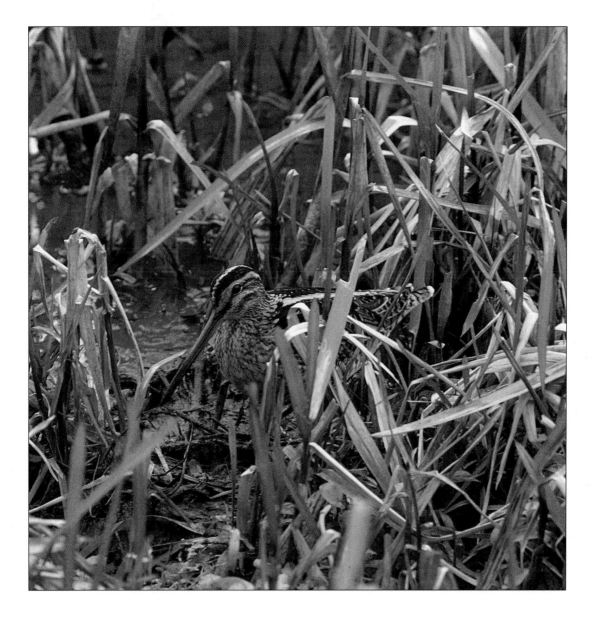

Opposite

Both banks are wet and boggy throughout the year and within this environment coarse grasses, sedges and rushes are prolific. Extensive beds of common reeds stand tall beside the river where cattle are unable to graze and trample them.

It is within the camouflage of this marshland that the snipe goes about its secret business. Its extremely long bill is used to probe into the soft muddy ground to seek out insects and, especially, worms. Most of the snipe's activity takes place during the hours of darkness; once the sun has risen the snipe rests amongst the heavy cover and relies on its excellent camouflage to protect it. If discovered, it will take off at the last possible moment with its characteristic zigzag flight.

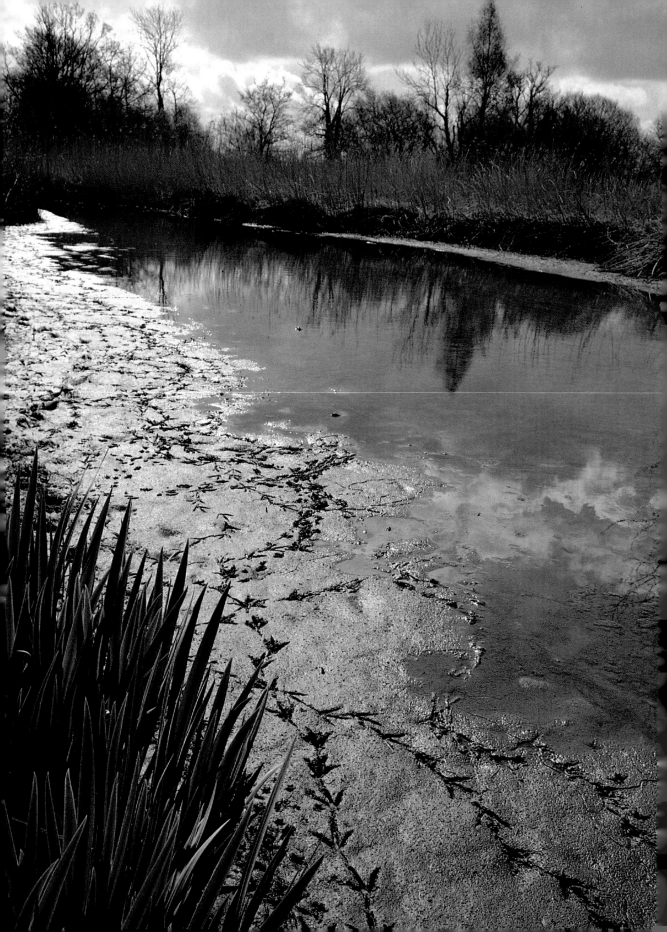

Footprints in the mud (*opposite*) are an indication of the wealth of wildlife that is associated with the river. Many birds are exclusive to the water's edge, but even the house-sparrow (*right*) has found it to be of benefit. Paddling and splashing until it becomes waterlogged and dishevelled, the humble sparrow enjoys a private bath in the shallows. It usually begins by dipping its chest into the water, then lowering its head and flicking water backwards over its body. Wing-flapping sends a shower of water in all directions, and to complete the process, vigorous preening takes place.

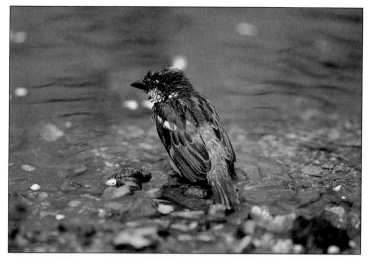

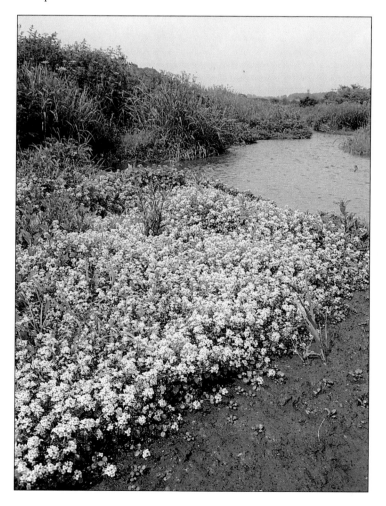

The massed watercress flowers produce a white carpet at the edge of the stream. This plant is especially prevalent on chalk streams, and in areas of mud with a constant supply of moving water. Flowers can be found on this plant throughout the spring and summer months, but the best show is around the beginning of June.

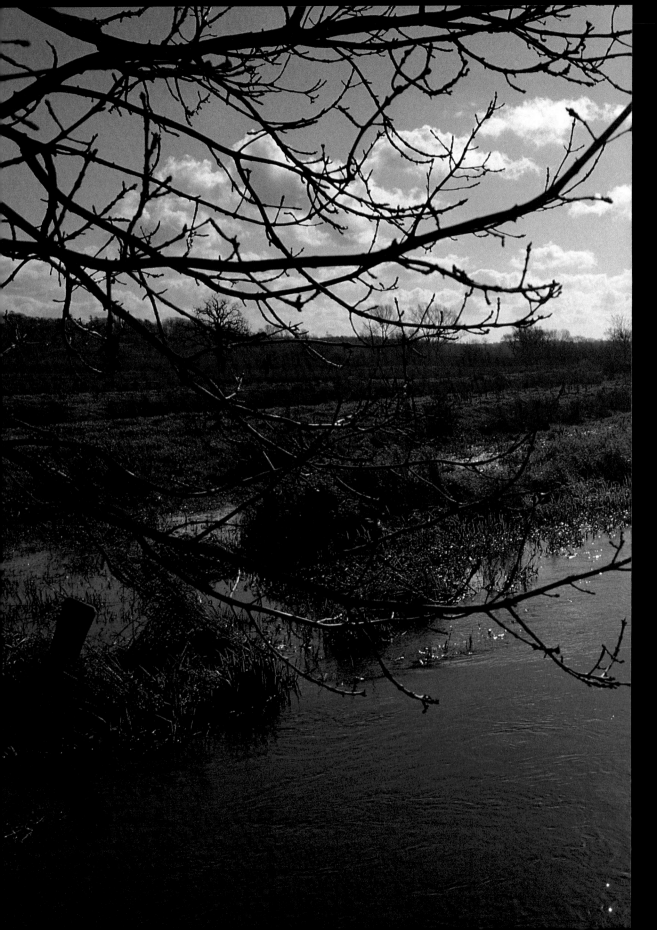

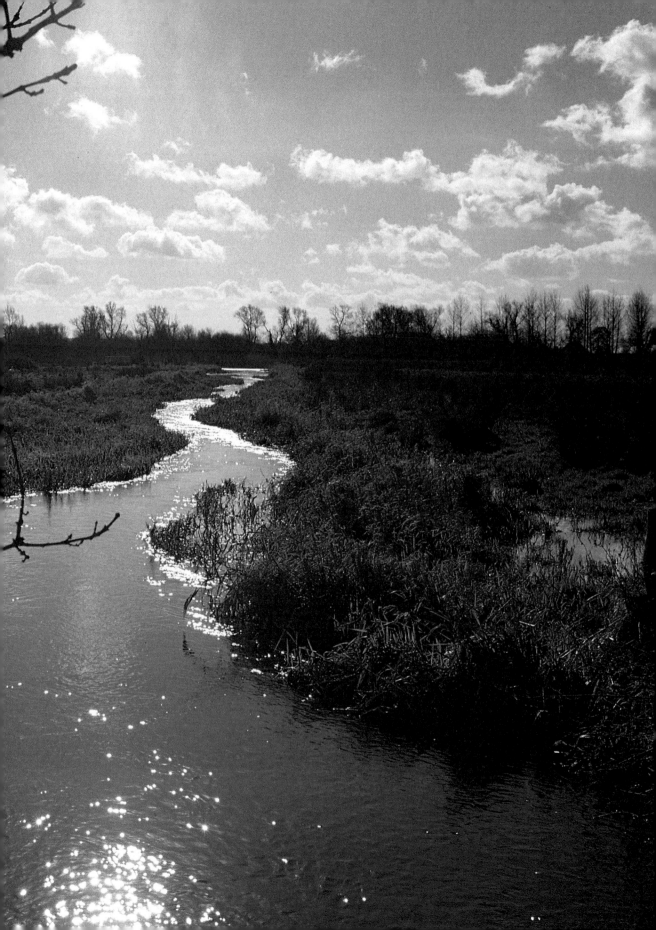

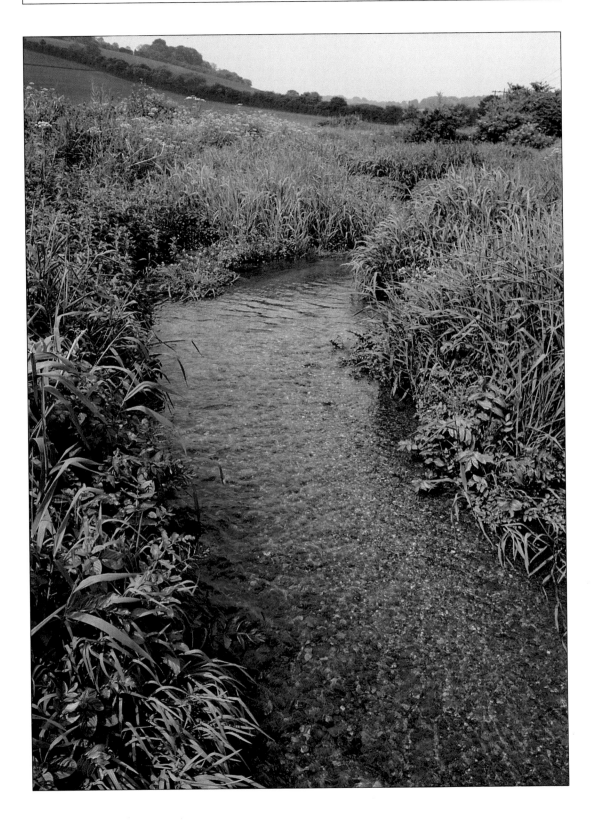

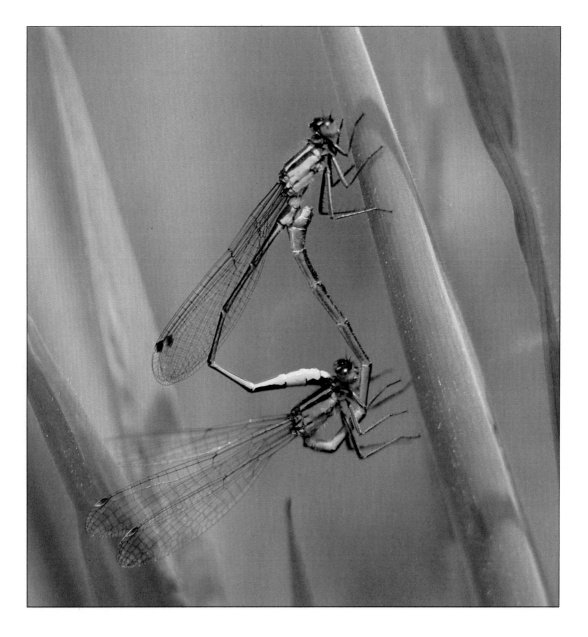

A familiar sight amongst the reeds of the river bank are the brightly coloured damselflies. Contrary to popular belief, both damselflies and dragonflies are completely harmless; they contain no sting, neither do they bite. It is not uncommon to see pairs flying in tandem during mating, the male using claspers at the end of his tail to hold the female around the neck. The blue male curves his body down and the female curves hers upwards between her legs, to complete mating. The common blue damselfly, shown here, is one of the most easily observed in Britain.

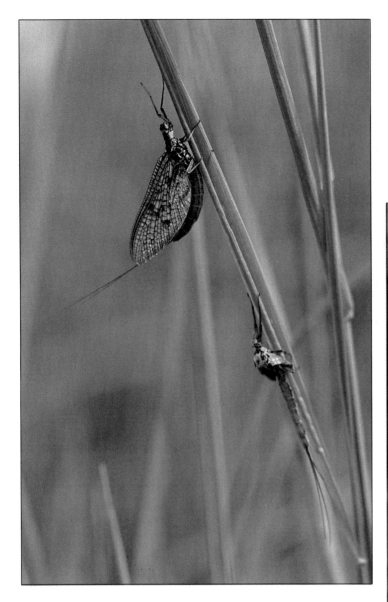

For most of its life the mayfly lives at the bottom of the stream, feeding on algae and other vegetable matter. It is preyed upon by a host of predators, from dippers to dragonfly larvae. Having spent a year within the confines of the water, it climbs up the stem of a reed until it is able to haul itself out into the air. Casting off its ugly nymphal skin, it emerges as a winged mayfly; the insect now has only about 24 hours to live. Within that time it has to moult from the sub-adult stage (or dun) into the true adult (or spinner); it also has to mate, after which the male dies, if it is not taken by a fish. After the mating flight the female lays her eggs in the stream, and then her life also ends.

One needs only to walk a few yards along the bank of a stream before hearing the cheerful song of a wren. It can often be a difficult bird to observe closely, due to its habit of skulking in dense vegetation and its cryptic, dull brown plumage. The male will construct several nests in secret cavities and the female will then select the one most suited to her needs. She lines the nest with mosses before laying the clutch of tiny eggs. The wren has learned to exploit the abundant insect life to be found along the river banks, and the greedy chicks are ever eager to accept another meal.

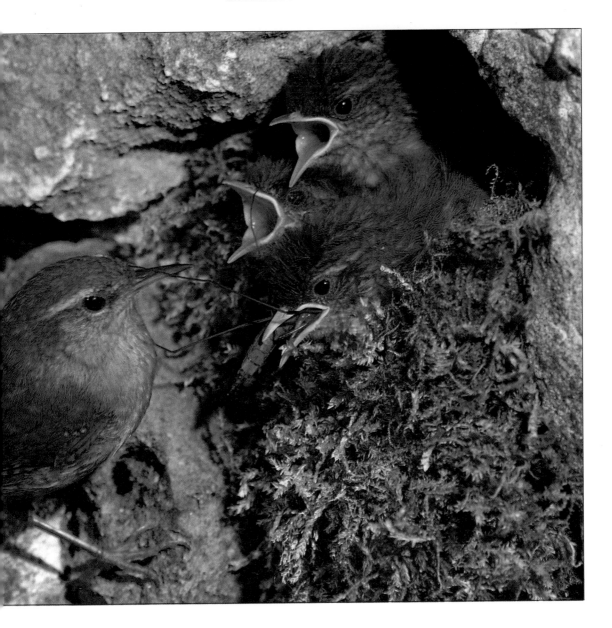

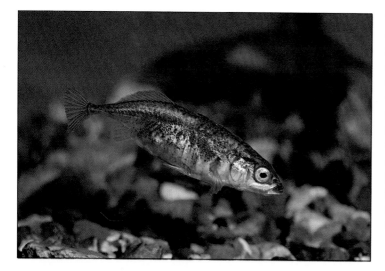

The three-spined stickleback cannot cope with the strong pull of the current, and so it chooses to live in stretches of the stream that are lazy and slow. Sticklebacks are the smallest of the British fish, and are unique amongst them in that they construct a nest from vegetation, and care for their young. In the spring, the male develops a bright red belly and throat, and bright blue eyes. Using these colours and a zigzag courtship dance, he entices the female into the nest that he has built.

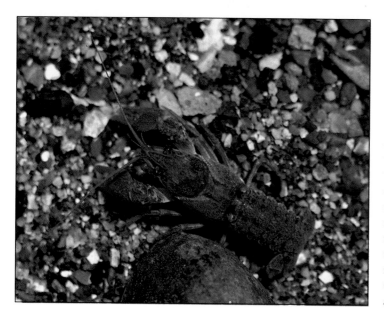

Unlike the stickleback, the freshwater crayfish prefers fast-flowing chalk streams. Here it has found a sheltered cavity beneath a large stone from where it will venture, mainly during the hours of darkness, to feed. It is a surprisingly quick predator; walking about the bed of the stream it snatches with its powerful pincers at insect larvae, snails and even small fish. It will also readily scavenge on any dead fish that are available. The crayfish rapidly out-grows its own skin and so moults several times each year. It is truly amazing to see an empty moulted skin complete in every detail, leg, pincers, and even slender antennae.

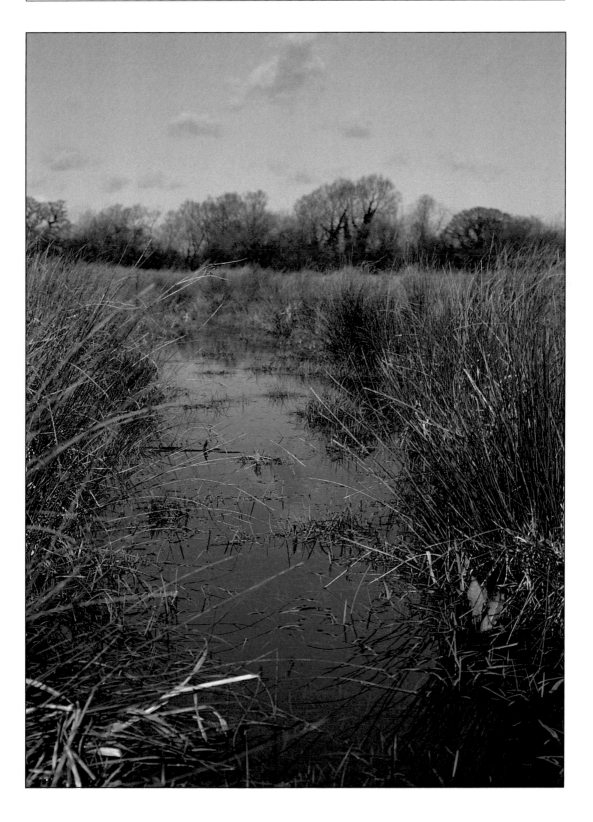

The water-vole is an attractive and inoffensive rodent of the river bank. It lives in a network of tunnels of its own construction. One or more of the tunnel entrances will be beneath the water level and act as an escape route, both to and from the water. It is an able swimmer although not powerful, and its high-speed dive from the surface helps it to escape many predators. Its diet consists of water and bank-side plants, and it may swim quite a distance along the river to reach a favourite one. The water-vole spends a great deal of time grooming itself, keeping its fur clean and waterproof.

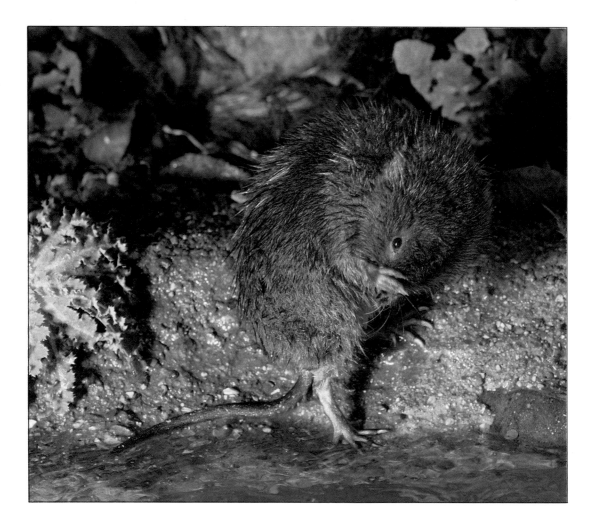

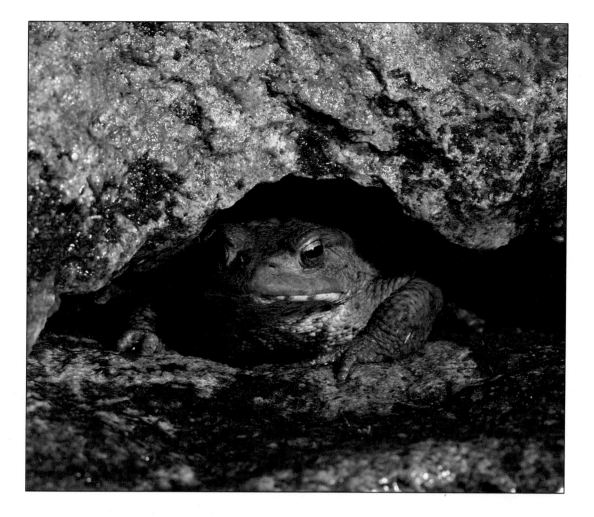

As the evening draws in, the common toad will creep laboriously from its hiding-place to spend the night in search of beetles, caterpillars, worms and many other suitable food items. Once daybreak arrives the toad will be back in its secret home, which it finds night after night with unerring accuracy. The toad may use the same day-time hideaway for many months at a time. Its navigational powers come into operation again in the spring, when it makes its way to the spawning pond or stream. It is probable that it will even find the pond where it developed as a tadpole many years before. A toad may take five or six years to grow to full size; and it is possible that its life span may be as much as forty years.

The still water of the pond permits different species of plants to develop. Duckweed, for example, would be washed downstream in the main river, but here in the quiet backwater it can proliferate. Growing amongst it is the water fern (*left*), another plant whose roots never become established in the soil. They float on the water and, at the same time, draw nourishment from it through roots that are suspended beneath the floating leaves. As a patch of water fern grows in a mass of duckweed, a natural pattern is created of varied shades of green.

As catkins fall from the trees, many land on the water and are swept across the surface of the pond to create drifts among the reeds. Eventually they will become waterlogged, but now they create an abstract pattern of colour as they float on the surface.

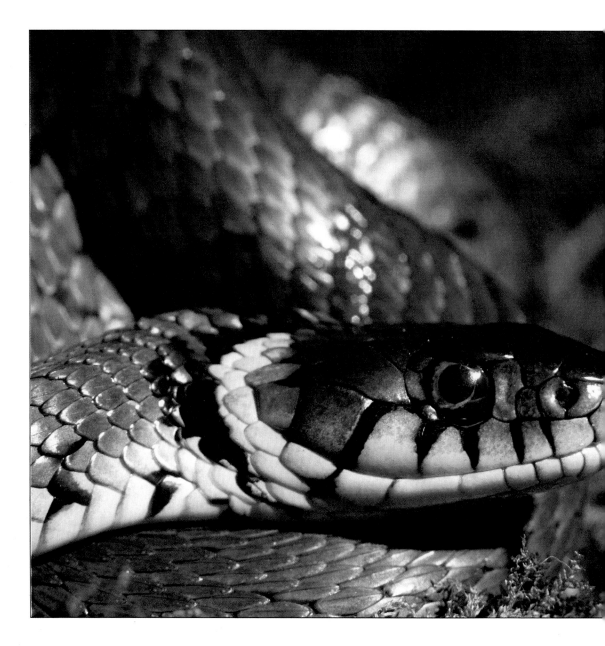

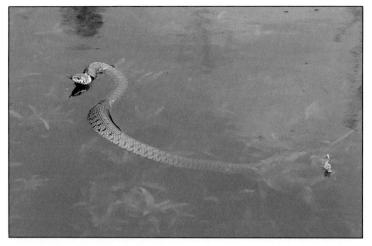

The grass snake is the largest British reptile and has strong associations with the river even though it can be found far away from water. Its main food items include frogs, newts, toads, and even fish on occasions, which illustrates this snake's ability in the water. It can swim with graceful ease, generally on the surface, but also underwater when in pursuit of prey. Away from the water it will take small mammals, lizards, birds' eggs and fledglings. The female grows to a larger size than the male, and can exceed four feet long. Between June and August the female will lay her eggs in a heap of fermenting vegetable matter or stable manure, and the heat of the fermentation will assist the string of leathery white eggs to hatch in six to ten weeks. The young are able to fend for themselves, feeding on small items of prey before hibernating during the winter.

Leaves of horse chestnut and maple flutter off the twigs to settle on the pond. Supported by the blanket of floating vegetation, the tints of autumn and decay contrast with the fresh green of the duckweed. During autumn, the duckweed can be so dense as to give the impression that it is solid enough to walk on. Heavy rain and a hard frost soon break up the mass of tiny floating plants, and rippling reflections can be seen in the pond once again: the blue of the sky, and autumn-painted leaves still hanging on the trees.

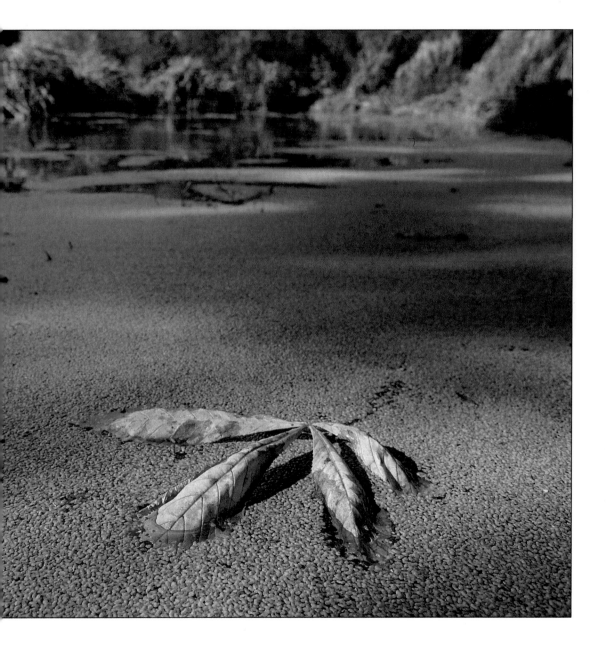

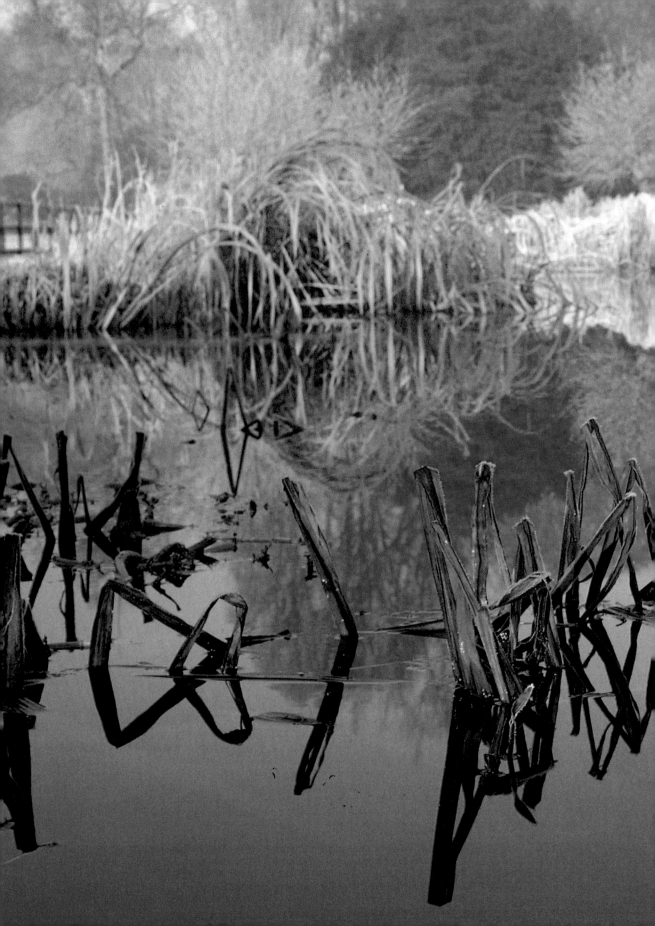

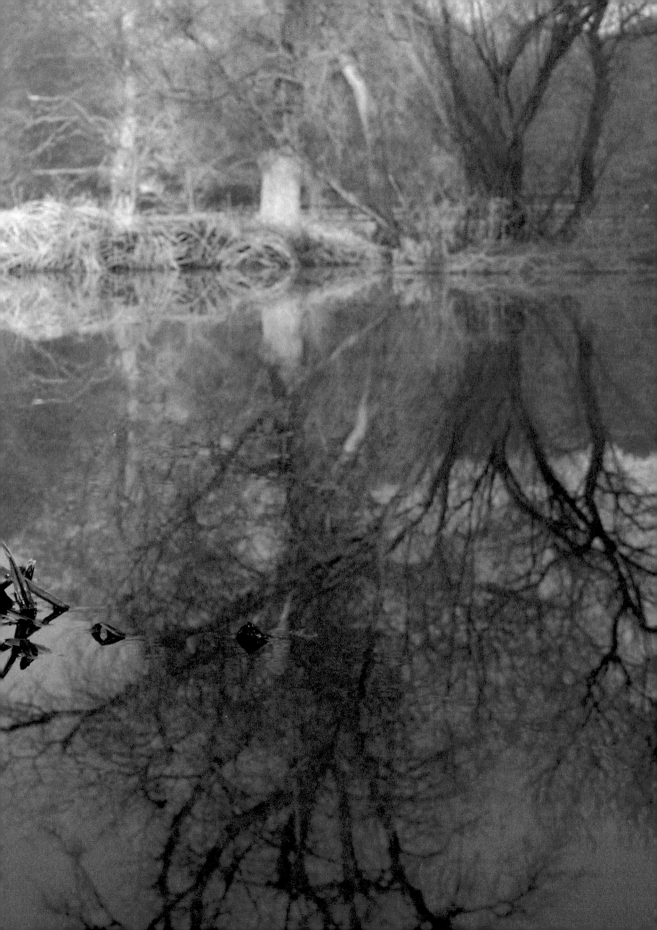

Moorhens breed along the length of the lowland river, and every pond has its own resident pair. It seems well adapted to its life both in the water and out, and as a result is very successful. Its long toes enable it to walk over floating vegetation as well as swim on the water; however, they do not hamper it as it sprints for cover over solid ground. Should the bird be disturbed on the water, it can dive and swim most effectively beneath the surface, or rapidly take to the air with a long scuttering run. Its food is very varied although largely vegetable, and includes the seeds, fruits and leaves of many plants, as well as insects and worms. The nest is built close to the water, either in the reeds, or in a nearby bush or tree. Both the male and female are involved in incubating the eggs, and later in caring for the black, fluffy chicks. Two broods of youngsters a year are usual and three broods are not infrequent.

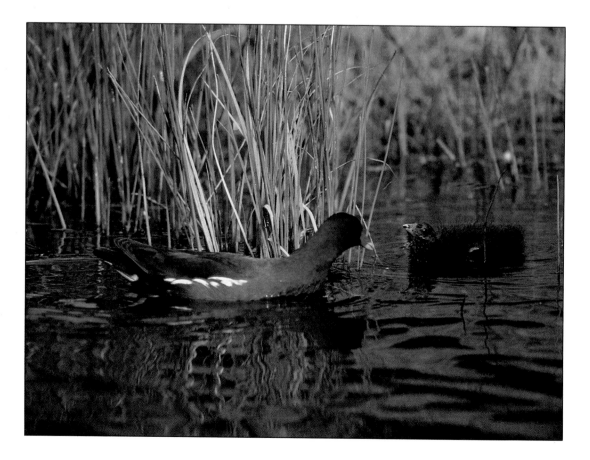

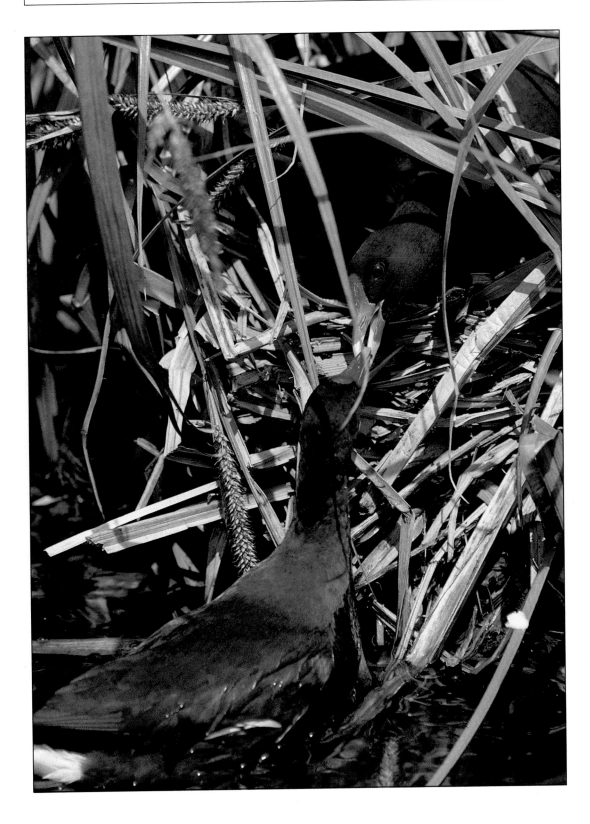

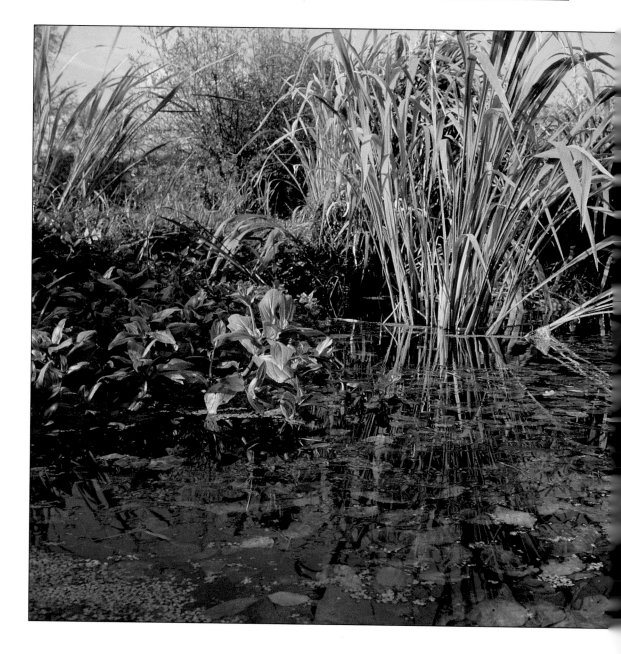

Most species of wolf spider are strictly land-based creatures. However, a few species have learned to exploit the pond by using the water surface as their hunting ground. Most of the time the spider moves on the floating plants, keeping at least one leg on the water surface to pick up vibrations that come through the surface film. Any sign of movement prompts it to investigate, and prey trapped on the water surface is quickly transported back to a suitable leaf to be eaten. It is able to walk on the water tension without becoming wet and, if in danger, is even able to haul itself under the water to hide beneath a leaf, breathing air trapped in the hairs that cover its body. A white cluster of eggs is attached to its abdomen until they hatch, and the minute young spiders are then carried on the abdomen of the adult until they are able to fend for themselves.

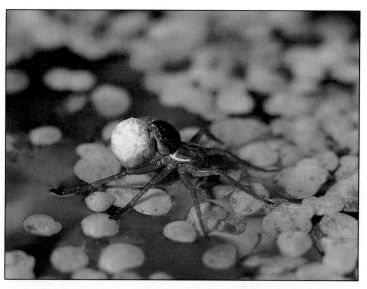

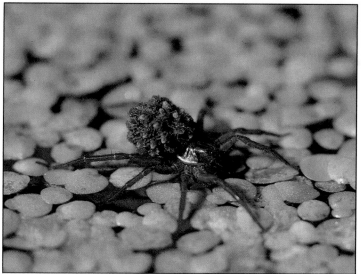

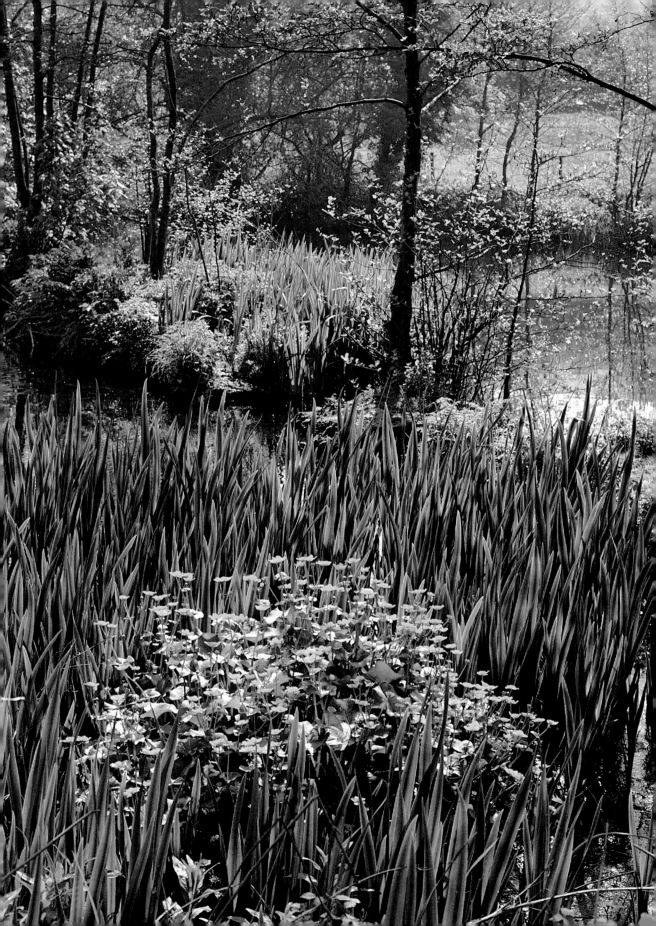

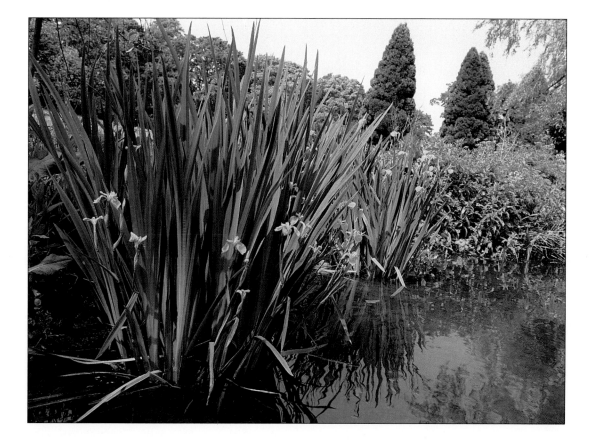

Kingcup (or marsh marigold) is a native perennial common throughout the British Isles. It enjoys damp ground on the edge of the pond and grows best in shaded spots. The yellow flowers may appear early in the year, when the leaves are only just bursting on the trees. This plant is surrounded by the spiky leaves of yellow flag, which will flower much later in the year. In some localities dozens of kingcups grow together creating a carpet of yellow.

It is not until May that the earliest flowers of the yellow flag unfurl. This plant is also referred to as the yellow iris and although it is a common sight on the river, it is always a pleasure to see these beautiful flowers in full bloom.

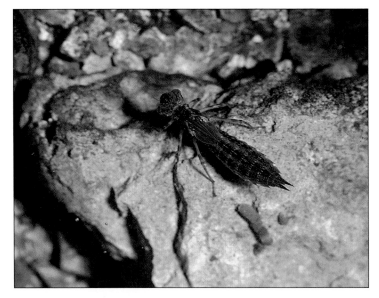

Dragonflies are effective predators at both active stages of their life. In the early stage, beneath the water, the nymph creeps towards its prey, then suddenly snatches it in a remarkable manner. The lower lip is very elongated and hinged in the centre, and a pair of movable claws is arranged at the tip. This whole device is folded away beneath the nymph's head and is known as the mask. When prey is suitably close, the mask is unfolded, the lower lip shoots rapidly forwards and the claws grab the prey.

A southern aeshna dragonfly has recently moulted its nymphal skin and is resting while its body and wings harden in the warmth of the day. Once the process is complete, it will first feed on other flying insects and then go in search of a mate. This may take the dragonfly many miles from the pond, but eventually it will lay its eggs in water to ensure the continuation of the species.

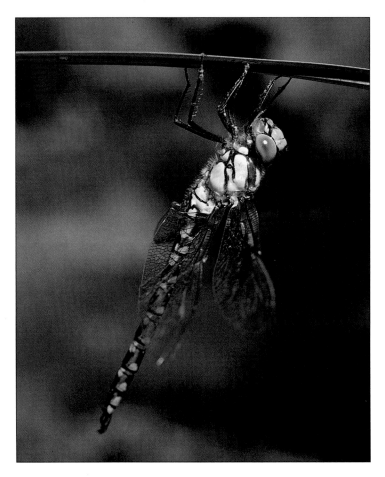

The pond is full of a great diversity of life, but both above and below the surface hazards to life abound. Insect predators are plentiful, and back-swimmers are among the fiercest of bugs. They are not to be confused with water boatmen, which are mainly herbivorous, because the back-swimmer feeds on tadpoles, small fish and insects. They breathe air from a bubble trapped around their body, and must return to the surface to renew their supply at regular intervals.

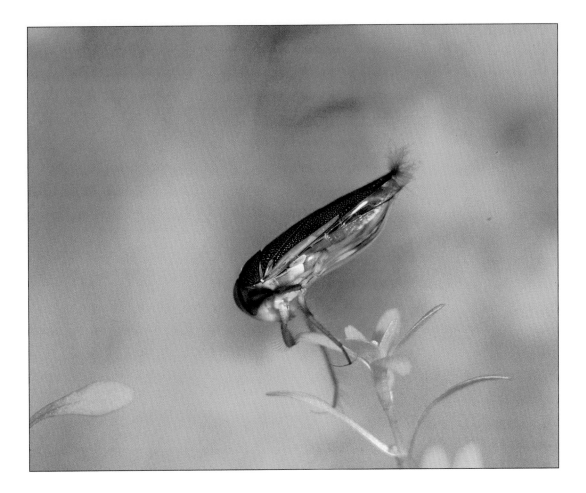

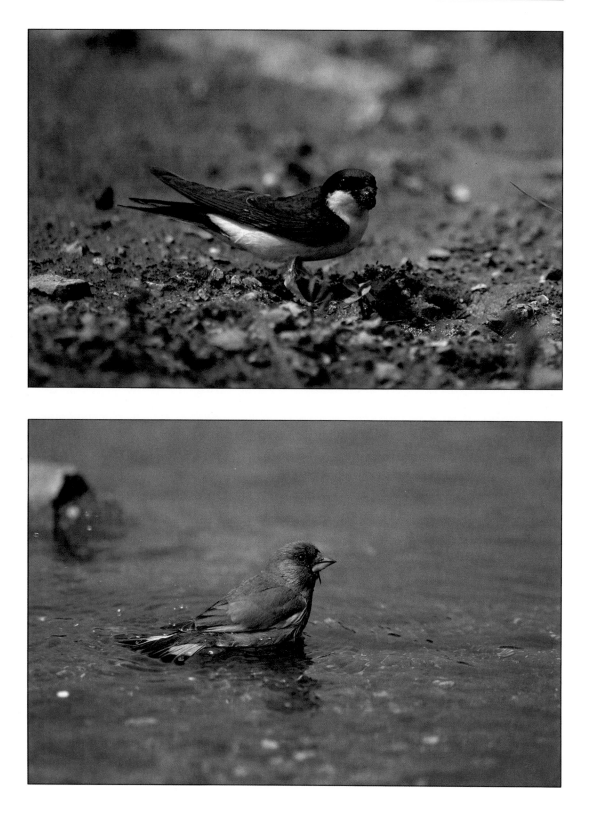

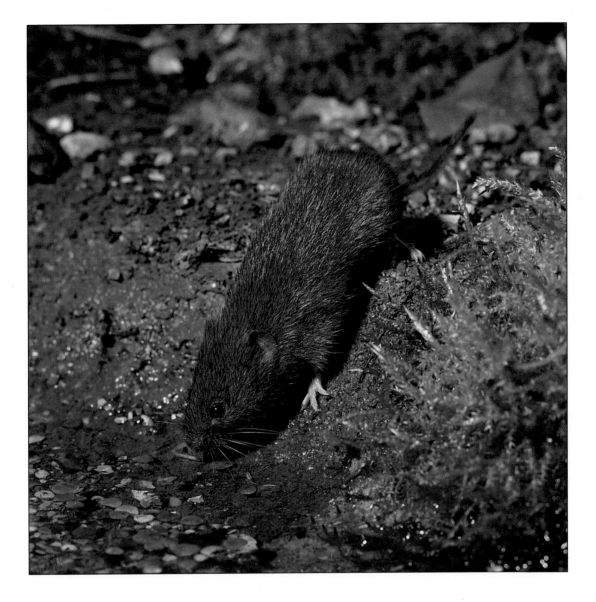

A house martin (*opposite above*) has chosen to nest under the eaves of a nearby farm building. Its nest is constructed of mud that has to be of the right consistency for the bird to carry and plaster it into place. The damp margins of the pond provide an ideal place to collect the mud, and dozens of martins drop in to carry it away.

Greenfinches (*opposite below*) are seed-eating birds and so receive little moisture from their food. For them, the pond provides a vital source of water. Almost every time the greenfinch visits the water, it not only drinks but seems unable to resist bathing.

Wherever the river travels, mammals, birds, insects and plants find benefit from its presence.

Many plants and animals that are not directly associated with the river or pond still benefit from or make use of the water in a variety of ways. To some creatures, such as the bank vole, it is an uncrossable barrier, even though the vole is a proficient swimmer. The river therefore forms the boundary of its world. However, it does provide the vole with a refreshing drink on a hot summer evening.

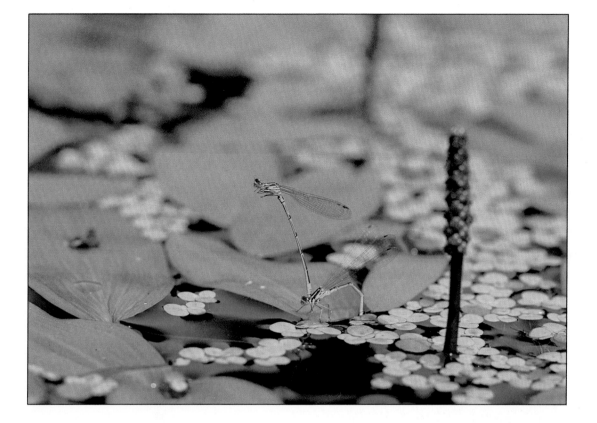

The delicate branching foliage of a horsetail can often be found close to the pond. The horsetails enjoy the damp environment of the water's edge.

Damselflies dance in tandem over the pond and settle on the edge of a floating pondweed leaf. The female damselfly pushes her tail into the duckweed and feels for a suitable place to deposit her eggs on the underside of a leaf. Each leaf of the pondweed seems to float precisely on the surface. Should the water be disturbed and the leaves become submerged or turned upside down, it will only be an hour or so before they correct themselves, and are floating perfectly again.

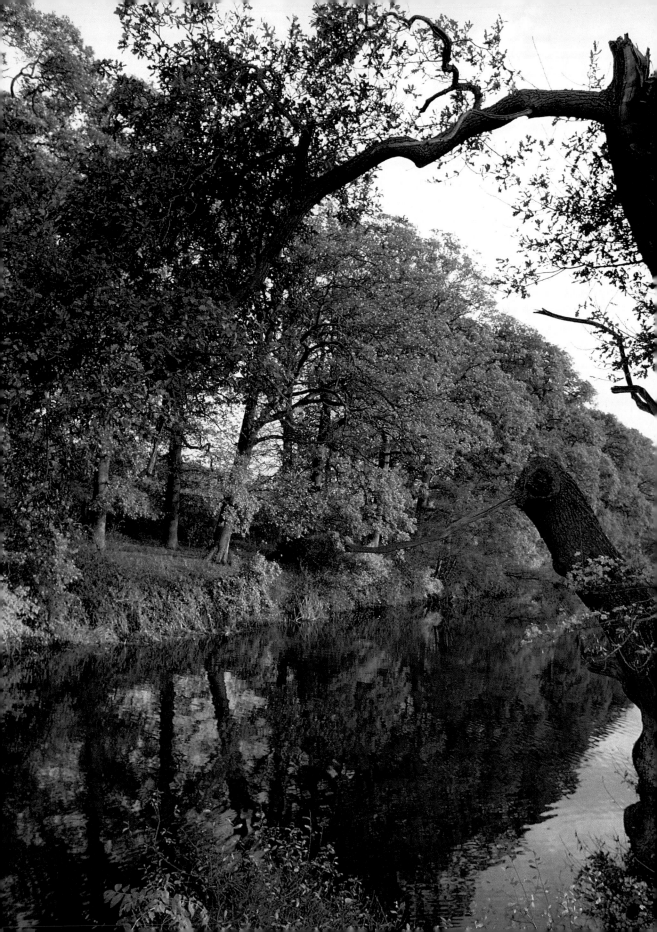

THE LOWLAND RIVER

TRIBUTARIES GATHER TOGETHER to join the main river as it meanders through the lowlands. It is bordered by the full variety of the countryside: water-meadows, grazing pasture, arable land and woodland.

During its 'middle age', or maturity, the river is more stable, cutting a steady course and providing life to the surrounding area. The wealth of nutrients it gleaned during its youth are deposited as its passage through the countryside slows down. This supply of nutrients is well exploited by a profusion of plant life that itself supports a multitude of insects; which in turn are the prey of many species of birds. The web of life is observed at its best on the banks of a lowland river.

Man once made use of the river's bounteous supply of nutrients by creating water-meadows. The river was encouraged to flood neighbouring fields during the winter months and thereby deposit the rich silt onto the pasture. This not only enriched the pasture; seeds from upstream were deposited at the same time, and in the spring many water-meadows were resplendent with wild flowers.

Unfortunately, because of the requirements of intensive farming, water-meadows are no longer common. Where they still remain, flowers such as buttercups, purple loosestrife, and ragged robin still abound.

All around, plants and animals respond to this ribbon of life; none can ignore it. To some it provides a method of transport, whether that is a seed from a plant, or a water-vole swimming to its favourite food plant. To others it is the edge of the world, an uncrossable barrier. Mammals both large and small drink from the edge, whilst fish can live only within the confines of its banks. Few river banks are cultivated and the lush vegetation found there provides a safe refuge.

Although the river is now slow and stable compared to its higher reaches, the changing seasons take their effect. During autumn, red, orange and brown-coloured leaves flutter off the trees to float downstream, leaving a tracery of bare branches that wait for spring, before once again producing delicate new growth.

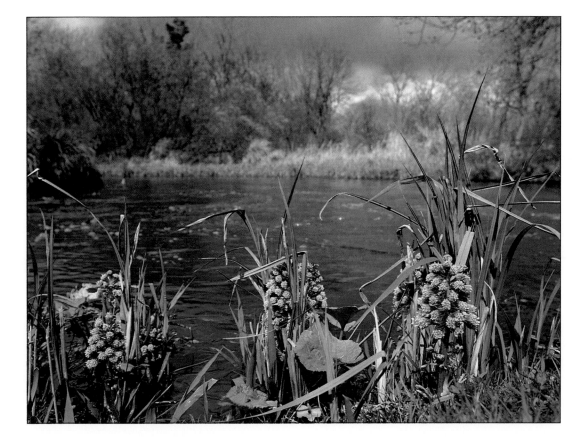

The yellow flag (*page 83*) bears a complicated flower that is designed to attract insects to carry its pollen to other plants for fertilization. It is particularly arranged so that heavy insects, such as bumble bees, can land on the down-curving petals. The fruits appear during July and August and split open to release the seeds. Often they will land in the water and be distributed by the flow of the current.

One unusual feature of the butterbur is that the flower-heads appear early in the year, before the leaves. However, once the leaves do begin to develop they can grow to an enormous size, up to two feet across. The butterbur plant is frequently found in water-meadows or on the banks of the river. It is said that the large leaves were traditionally used to wrap butter, and that is the derivation of its name.

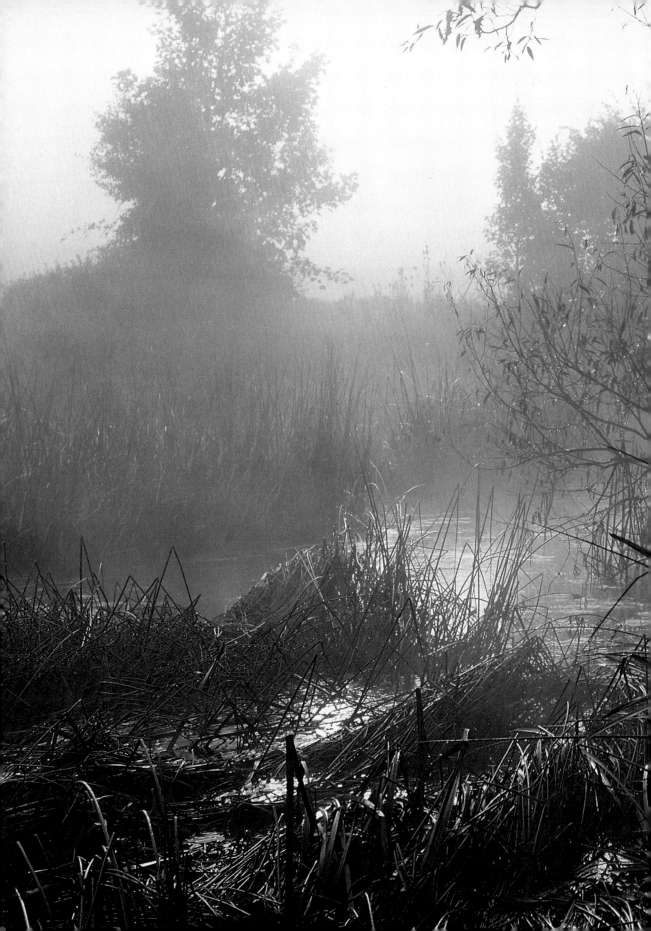

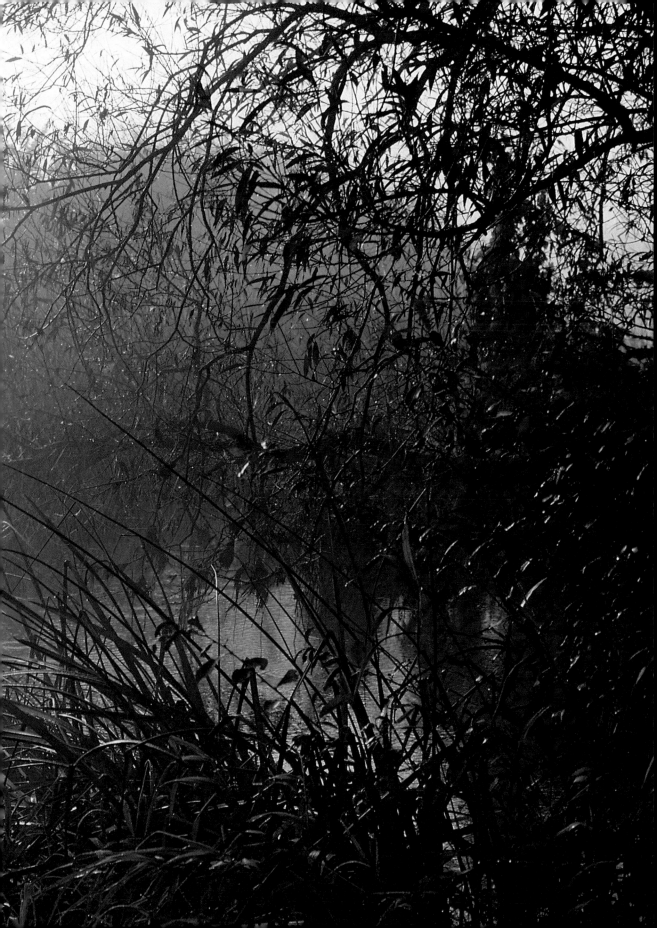

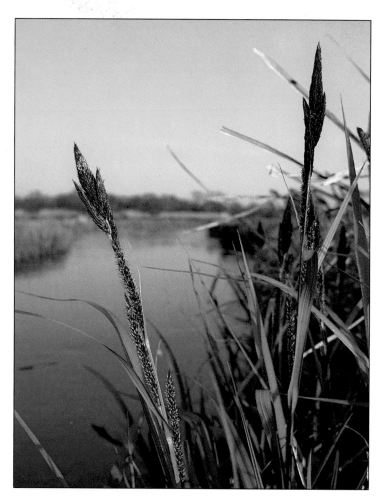

The creeping stems and tufted habit of the sedges help to hold the banks of the river intact, and the strong roots resist the effects of erosion.

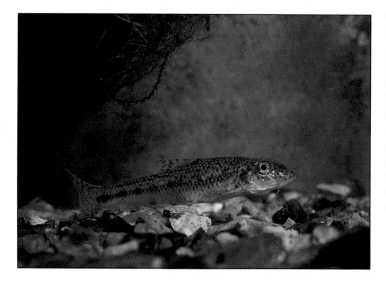

The flattened belly and drooping barbels on either side of the mouth are sure indications that the gudgeon is a bottom-feeding fish. Facing upstream and nosing along the gravel bed of the river, the gudgeon detects food using its sensitive barbels. It has a strong shoaling instinct, and will shoal not only with fish of the same species, but also with others of a similar size. When fully grown, at about two or three years, it may reach six inches in length.

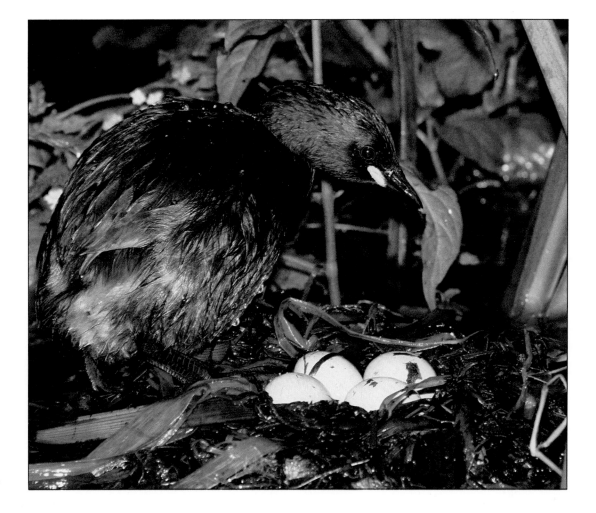

The little grebe is often referred to as the dabchick, and is the smallest and most numerous of the grebes. Although common, it is not often seen, due to its secretive nature and ability to dive beneath the water at any sign of disturbance. It can swim extremely well underwater, where it feeds on insects and small fish. During the spring, the floating nest is constructed from a mound of rotting vegetation collected from the river and lodged among reeds or overhanging branches. Every time the adult leaves the nest it covers the white eggs with nest material, hiding them from view, and on its return uncovers them again before brooding.

Trees and other plants flank the lowland river and hemp agrimony has established itself amongst the prolific vegetation of the river bank. The mass of pink flowers that are produced in July are popular with a great variety of insects. This plant is not related to hemp, but the leaves have a superficial resemblance to hemp leaves, hence its name.

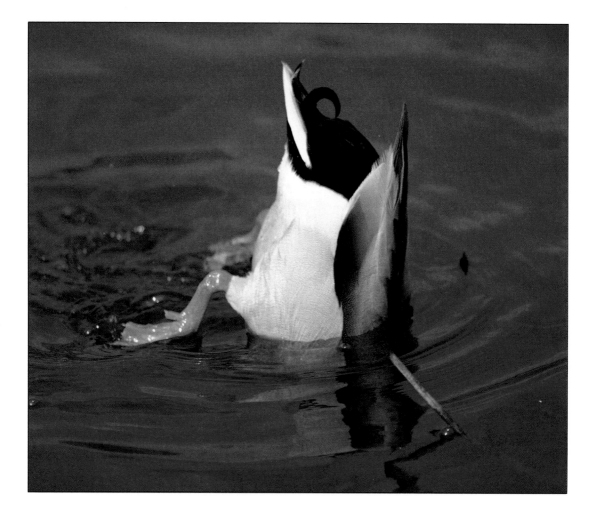

The familiar duck found on every pond, lake and stretch of river, is the mallard. Its feeding activities are well known as it up-ends in the water, reaching down to the bed of the river to gather anything that is edible; insects, worms, snails, grain, vegetation and crusts of bread thrown in by passers-by. Only the drake is so smartly dressed; the female has a dull, camouflage-brown plumage. In town parks the mallard is extremely trusting of man, but in the country, where it is shot for sport, the mallard rests with half an eye open and is quick to fly off at any sign of danger.

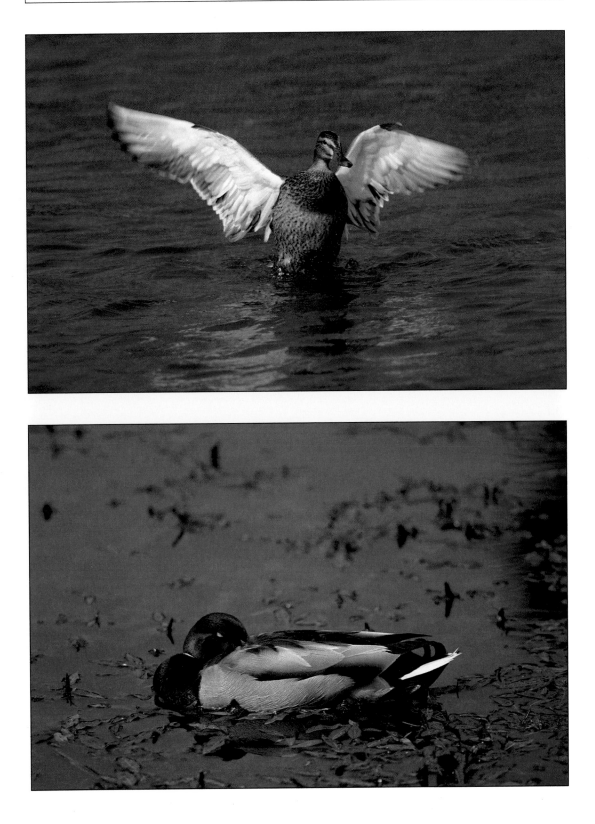

The colours of each season are re-
flected in the river; as the riverside
trees turn to orange and brown, so
the water reflects the time of year.
Breaking into this pool of colour
comes a pure white swan, bringing
quiet and tranquillity.

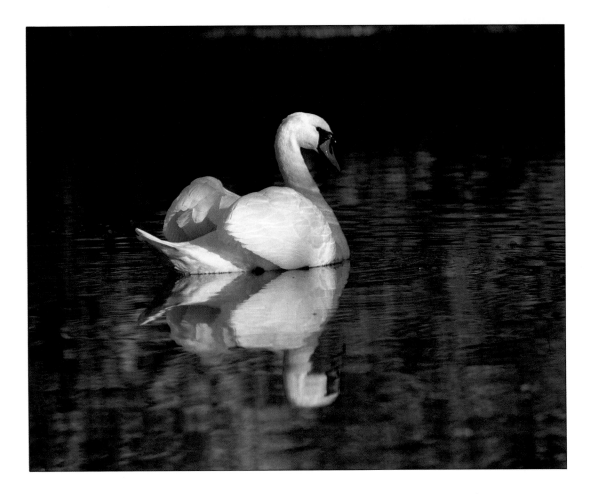

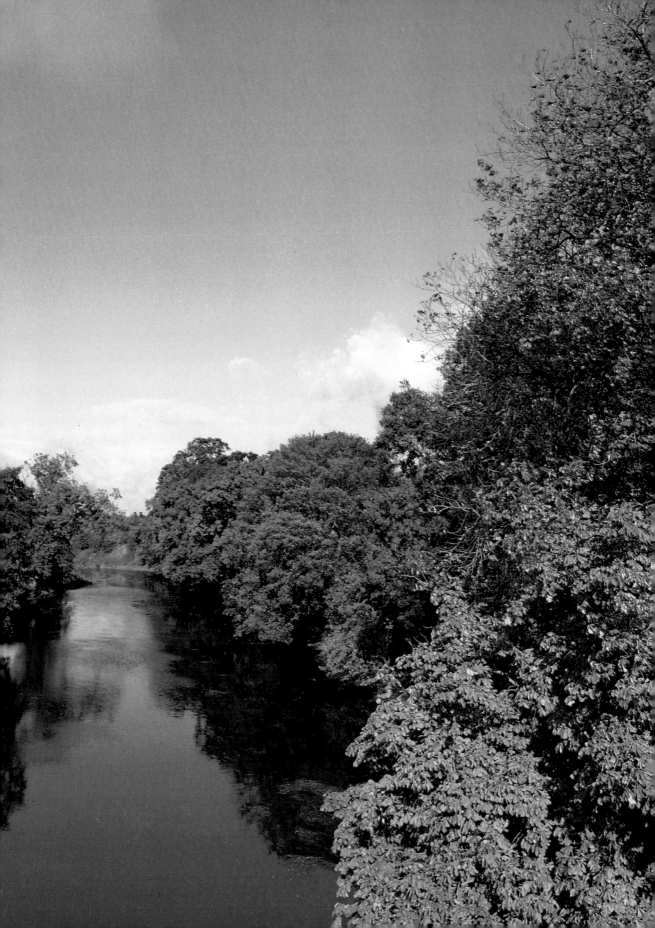

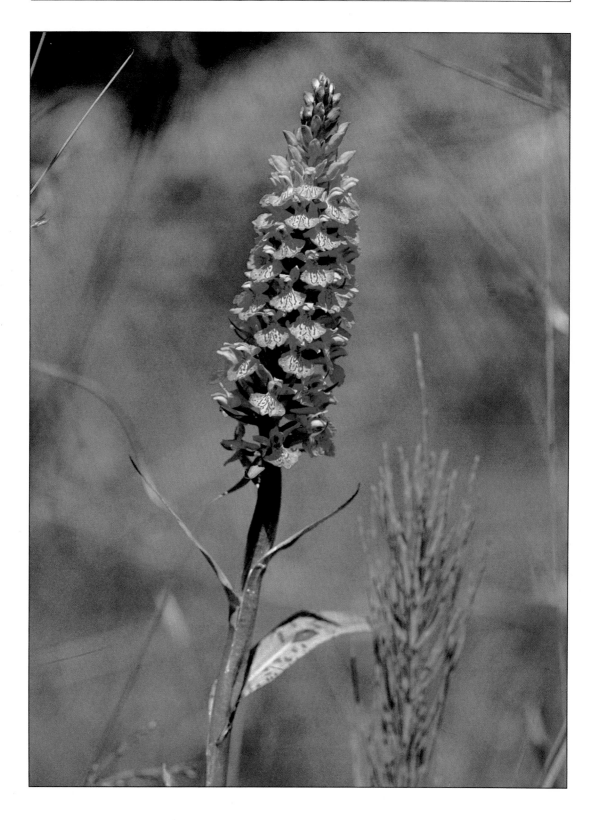

Although common, the southern marsh orchid (*opposite*) is one of the most beautiful of its kind. Flowering from June to August, the flower spike may be four inches long. It thrives in the damp soil of the river bank, and in the water-meadows (*above*) that lie within the river valley.

Lady's smock (*right*) is also known as cuckoo flower, and is a plant of damp water-meadows and river banks. The delicate pink or lilac flowers open in April and brighten dull, damp corners with a flush of colour.

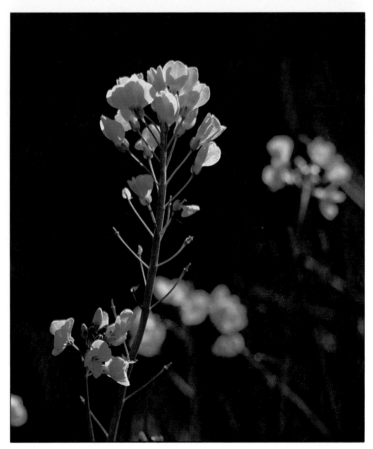

By August the greater reedmace, often called bulrush, has completed flowering and the female parts of the flower produce the familiar seed head. These dark brown, club-shaped fruits (*below*) last well into the autumn, when they begin to separate to produce a huge quantity of fluffy cotton wool that carries the seeds away on the breeze (*right*).

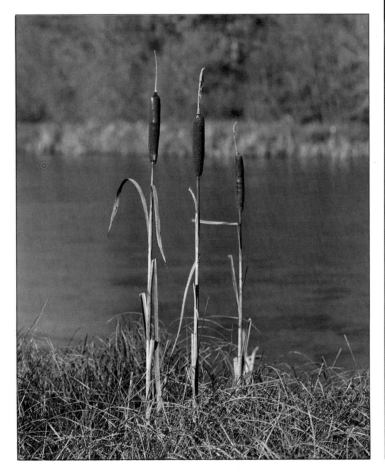

The drake teal dabbles on the water surface, searching for floating seeds and midge larvae. It will up-end in shallow water to feed on tiny snails from the bottom. Teal fly low and fast, and when large numbers fly together, they form tightly-packed flocks that twist and turn in unison in a similar way to waders. Equally at home on the estuary as on an inland river, and often breeding on moorland pools, the teal is the smallest British duck.

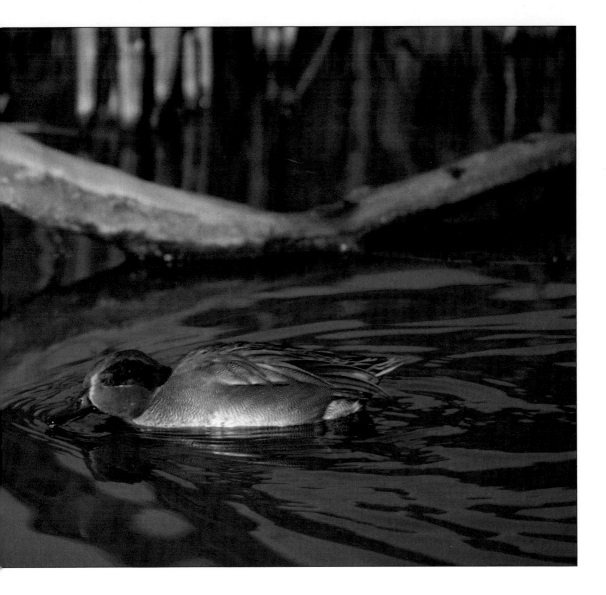

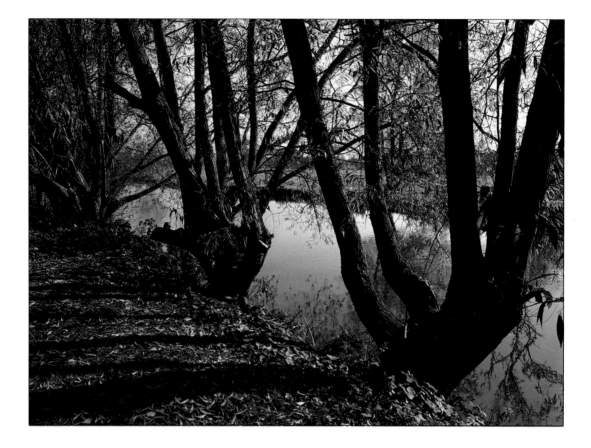

The plentiful supply of water encourages the growth of plants, and trees are not slow to take advantage of this. Some trees, such as willows, are particularly associated with water, whilst others, like the oak trees, simply make use of the benefits that the river has to offer. It would appear from the regular spacing of these willows (*above*) that they were planted many years ago and then pollarded.

The oak leaves have fallen on to a quiet part of the river (*opposite*) where they will float for a while before sinking and decomposing, adding to the nutrients carried in the water.

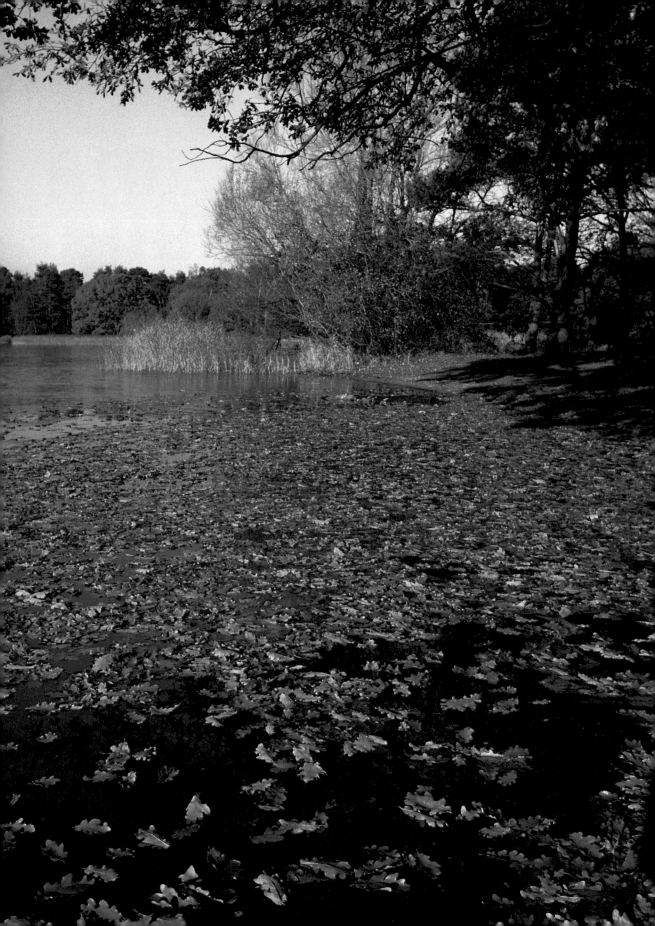

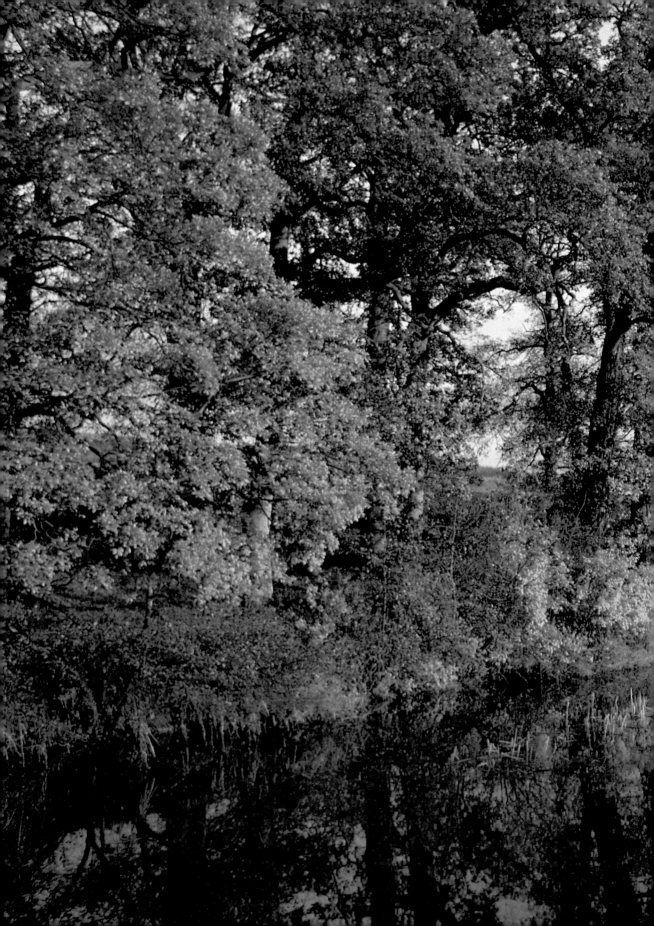

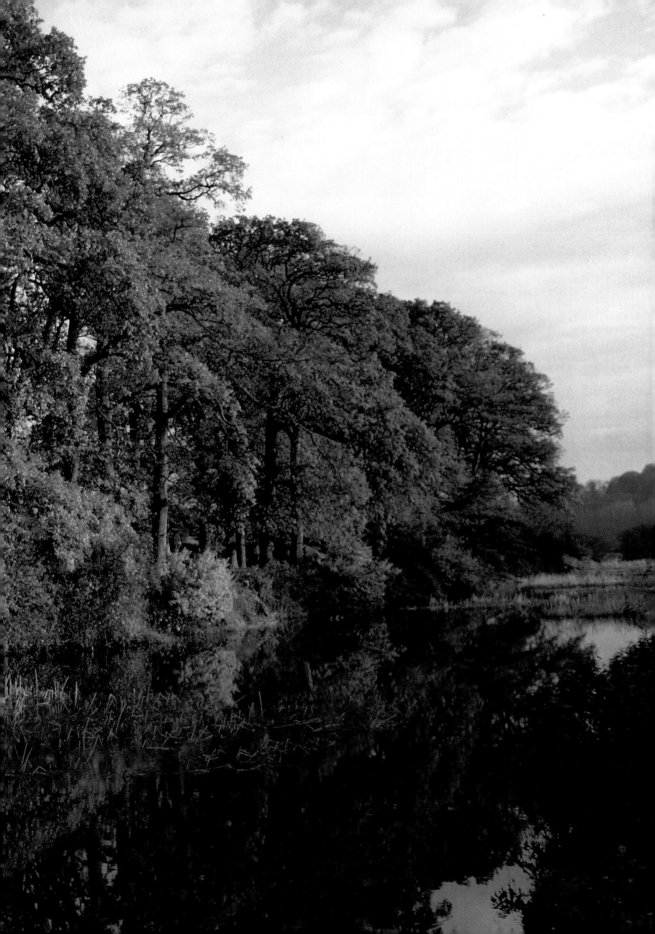

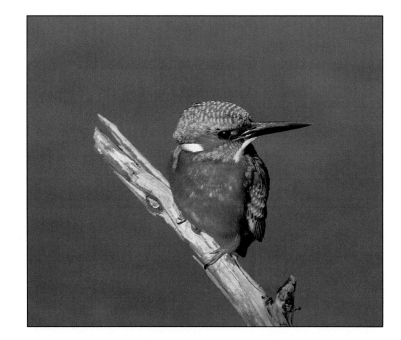

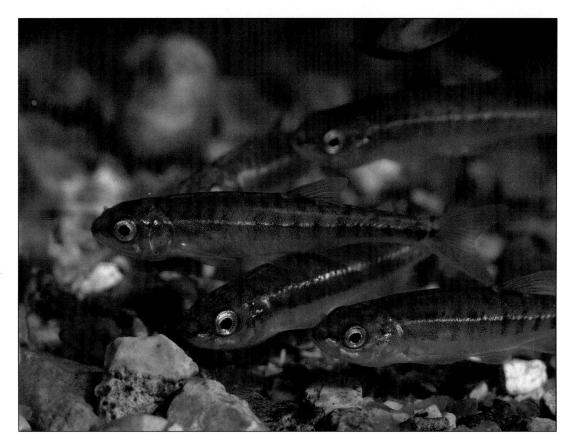

Often referred to as the jewel of the river, the kingfisher, as its name suggests, is an efficient hunter of fish. Although this bird will take any species of fish, it is often found where shoals of minnows are readily available. During the summer, thousands of minnows swarm together (*opposite below*) in the warm waters of the shallows. They move in unison to the current of the water and provide a source of food for many of the river's inhabitants, from pike to kingfisher. Minnows are not slow, however, and it takes a lightning-speed dive from the kingfisher to snatch one out of the water. With water droplets flying, this beautiful bird carries the fish back to its perch, where it will stun it, before swallowing the fish head first.

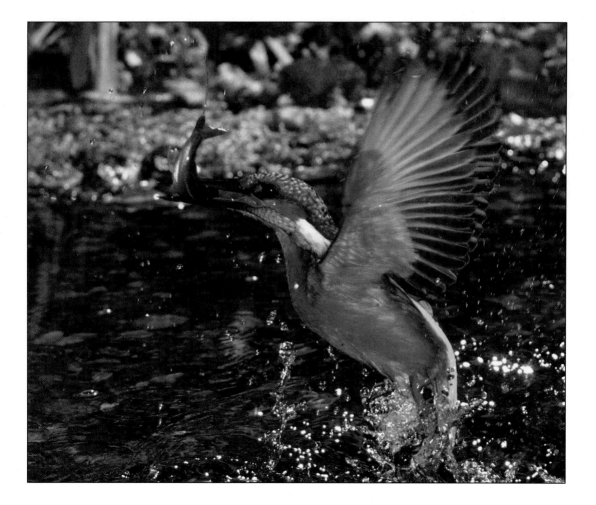

Flood meadows are rich in nutrients that have been carried downriver and deposited when the flood water subsides. This way of fertilizing the soil was considered for many centuries to be good agricultural practice, but the maintenance and operation of ditches and sluices make it very labour intensive, and so today water-meadows are not common. In this environment, which is flooded for part of the year, buttercups thrive.

When the water subsides, they are protected from being grazed by their acrid and poisonous juices, which are distasteful to animals.

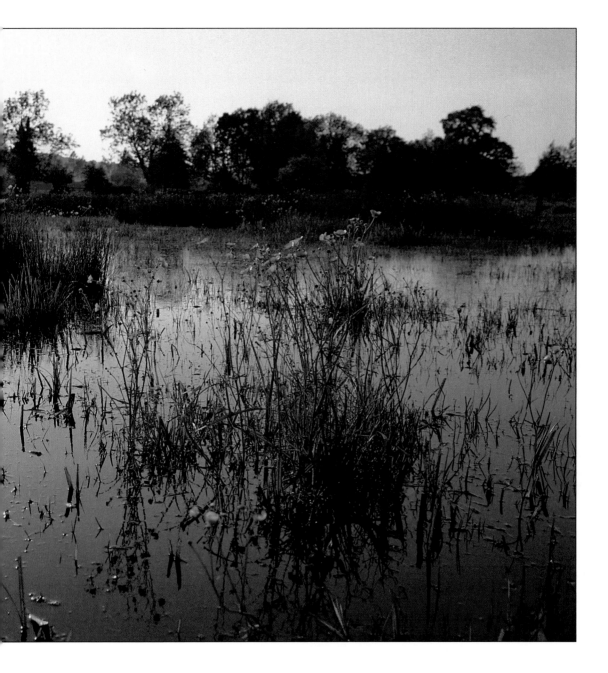

Purple loosestrife is found in the later months of summer. Because it always grows in close proximity to the river it is not affected by a drought and can afford to produce its flowers later in the year. The densely-packed flowers form an impressive spike between July and September, and is eagerly visited by pollinating insects. It grows each year from the perennial rootstock and can often be found in large clumps. Despite its name, it is not related to the yellow loosestrife that also likes the river bank.

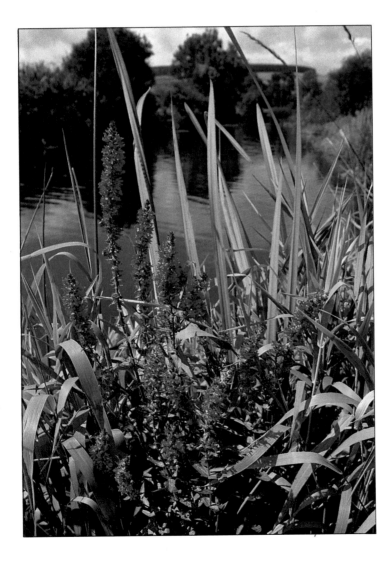

Supported by the river, dense reed-beds provide a habitat of their own, supporting a profusion of wildlife. Bindweed twists around the reed stems, using them for support as it climbs towards the light. Insects crowd into the mass of leaves, and themselves provide food for the reed warbler. The reed warbler builds a nest that is supported by the reed stems, and uses the nearby grasses and mosses to construct a beautiful, deeply-cupped nest. A deep cup to the nest is particularly useful when the reeds sway in the wind. Hidden within the reeds, the warbler is difficult to observe but the churring song is often heard. The reed warbler is one of the birds that suffers from the parasitic activities of cuckoos. Having gone through the efforts of nest-building, egg-laying, and incubation, the reed warbler's efforts often turn out to be on behalf of a cuckoo's chick, and this chick demands every scrap of food that the adopted parent bird can carry.

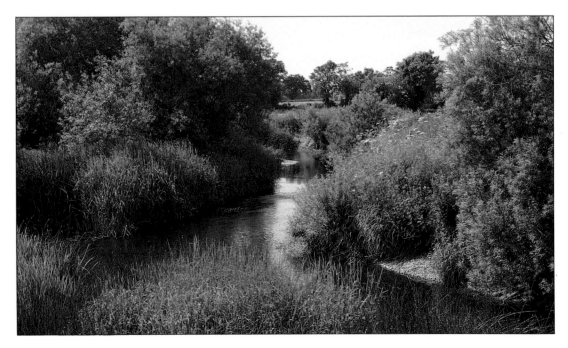

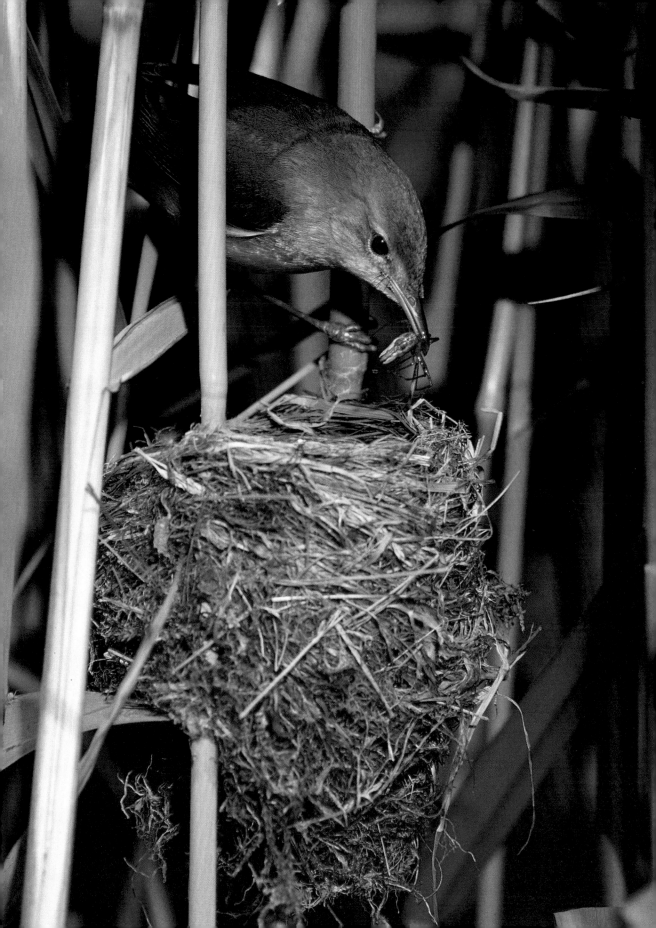

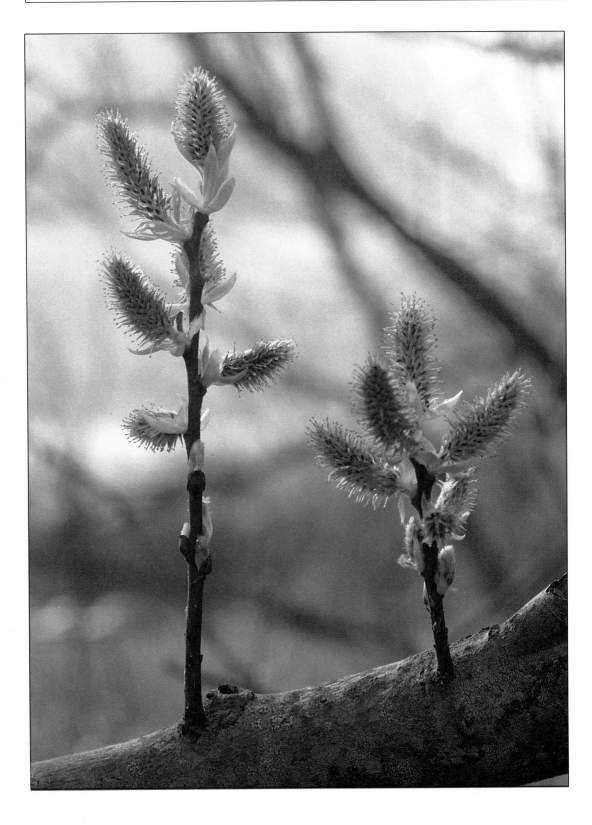

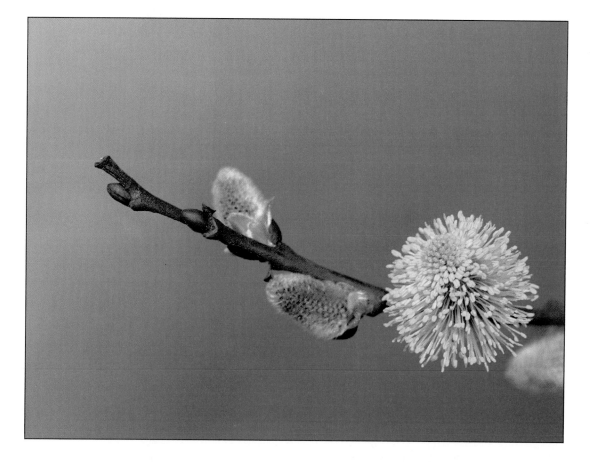

The common osier was often cultivated and coppiced for making baskets, hurdles, fish traps, bird cages, and so on. However, as this industry declined, so the numbers of this small tree have also declined; it is not a long-lived species. Nevertheless, it is still commonly found in areas of damp soil. The catkins open in April and May, before the leaves appear.

A small tree that is known by many names – goat willow, great sallow or, when catkins are present, pussy willow – grows close to the river. The catkins develop on the bare twigs during March and April, the male catkins turning into the bright yellow puffs that are so familiar. This tree is host to a multitude of insects and is very good for wildlife; the seed-down is even collected by finches as a soft nest lining.

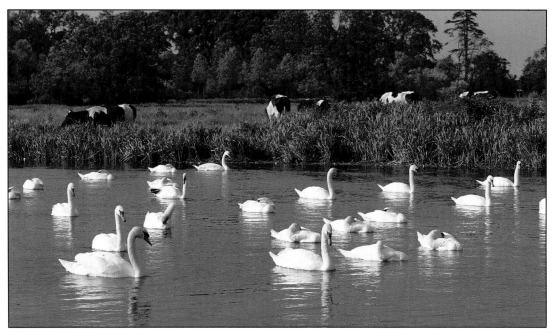

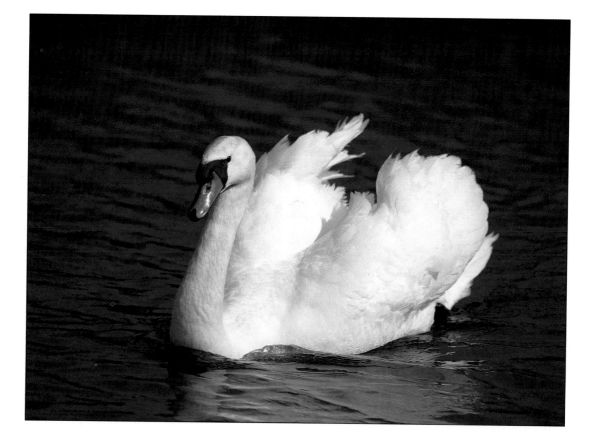

The semi-domesticated mute swan is a familiar sight on all ponds, lakes and rivers. It is probably the most instantly recognized of all British birds, although there are two other swans with which it could be confused, the whooper and the bewick's swan. At times large numbers of mute swans can be found gathered together. During the summer, these will mainly be young, non-breeding birds, but huge gatherings of all ages can be seen on some estuaries during the autumn and winter. When feeling aggressive or dominating, a mute swan will swim with wings held up and slightly away from its body. It is a very regal posture that is popular with on-lookers as it parades along the river. A pair will raise a brood of around five to eight cygnets each year, hatched in a nest of vegetation and down. The chicks are cared for by the adults, and it is always a delight to see several little cygnets scrambling onto the back of a parent and riding in luxury along the river.

Early morning mists hang low over the river, draining the bright colours of autumn from the landscape. Moisture in the air clings to a spider's web, creating a pattern of fragile, jewel-like droplets that will soon disappear in the warmth of the day, or in a gust of wind. As the sun rises, the mist clings to the river valley, and rays of light radiate through the trees before it is finally dispersed.

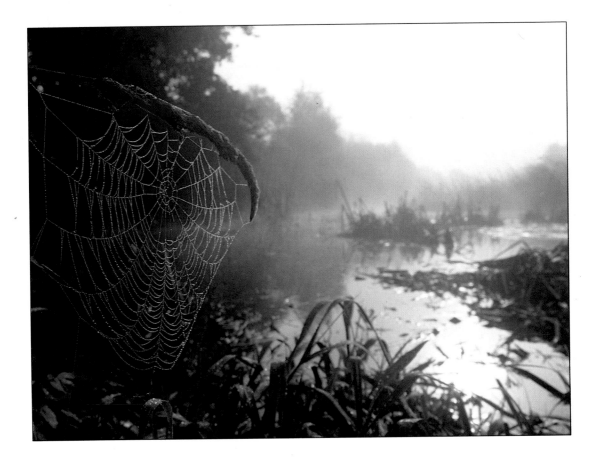

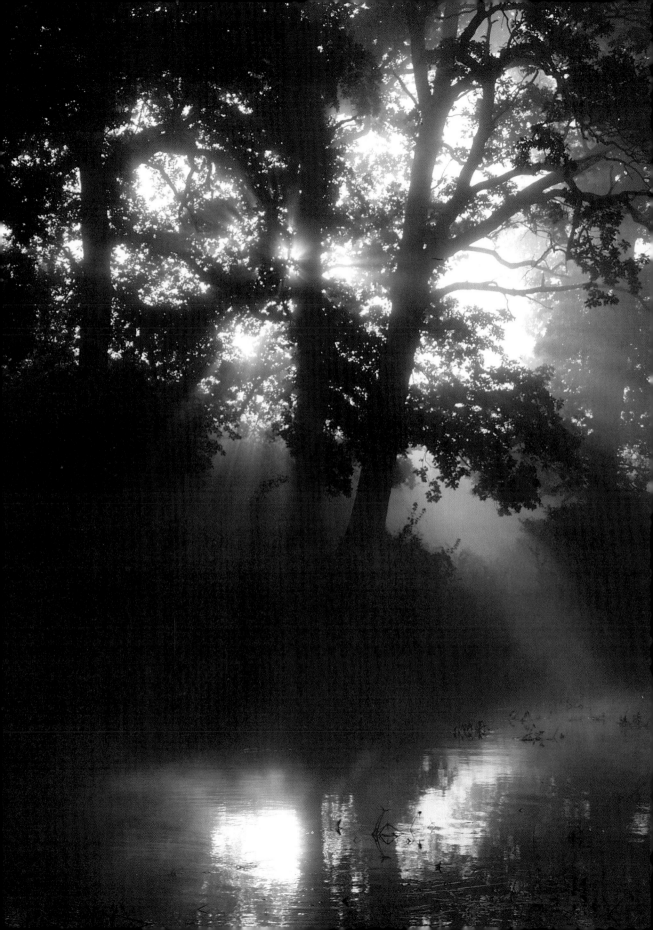

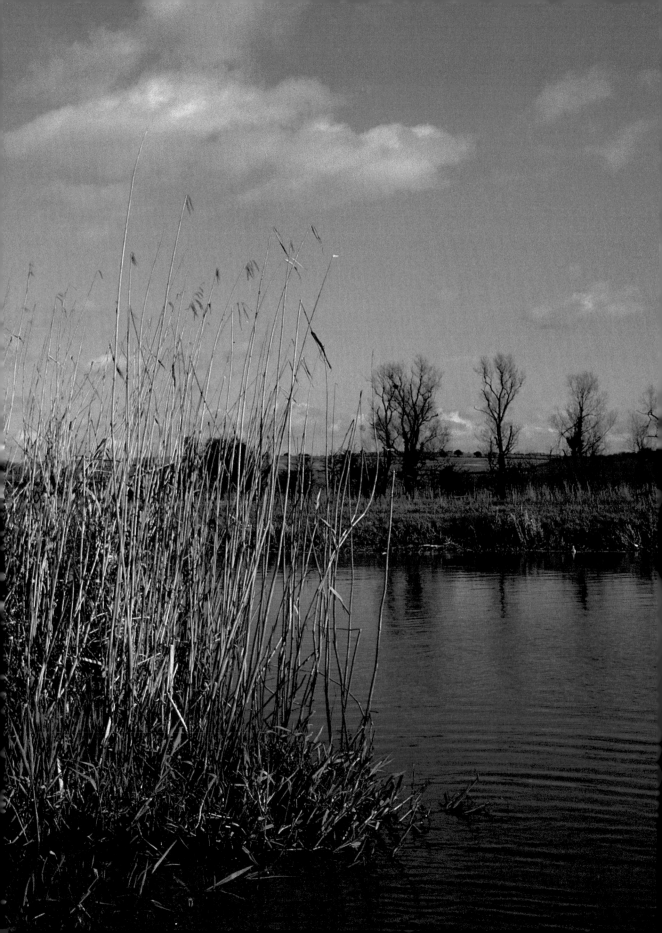

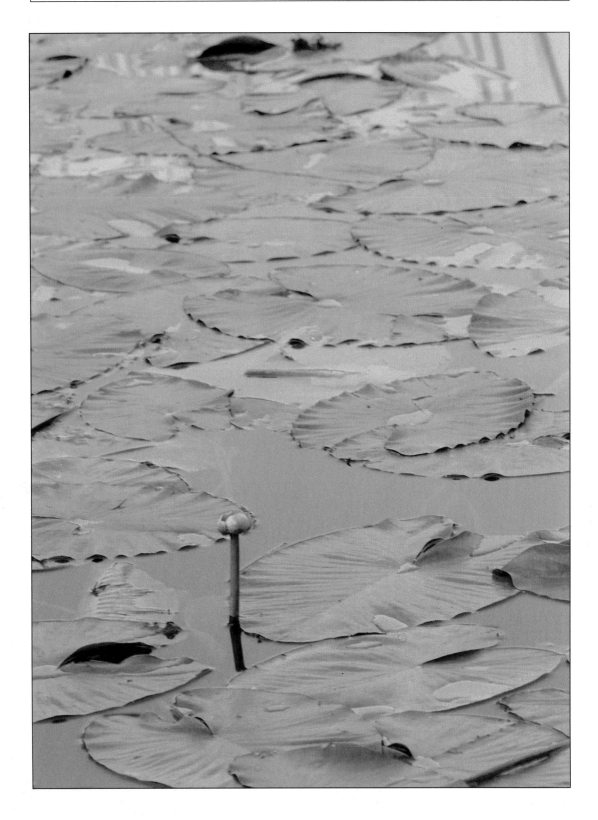

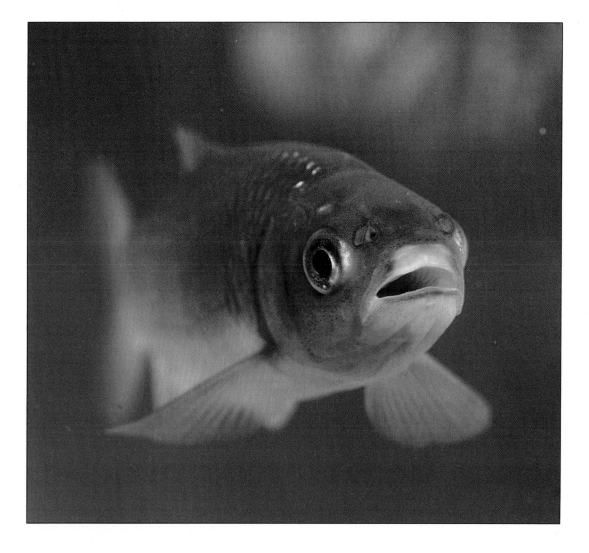

The leaves of a yellow water-lily cover a quiet patch of the water. On a bend in the river, the flow often slows down and the water becomes shallow and muddy, which is ideal for this plant. Beneath the surface the lily produces cabbage-like leaves that are quite different from the leaves floating on the surface. In midsummer, long stems rise above the water to support the flowers, which are bright yellow and almost spherical. The yel-low water-lily is also called brandy-bottle because of its scent, which is similar to alcohol, and the brandy-bottle shape of its fruit capsules.

The chub is widely distributed throughout Britain, wherever a low-land river makes its way through the countryside. It is a popular fish with anglers for it can grow to over 10 lb and provides good sport. Larger chub feed on other small fish, whilst smaller specimens feed mainly on insects and a small amount of plant matter. The younger and smaller fish are usually found in shoals, whilst the large chub is a lone fish.

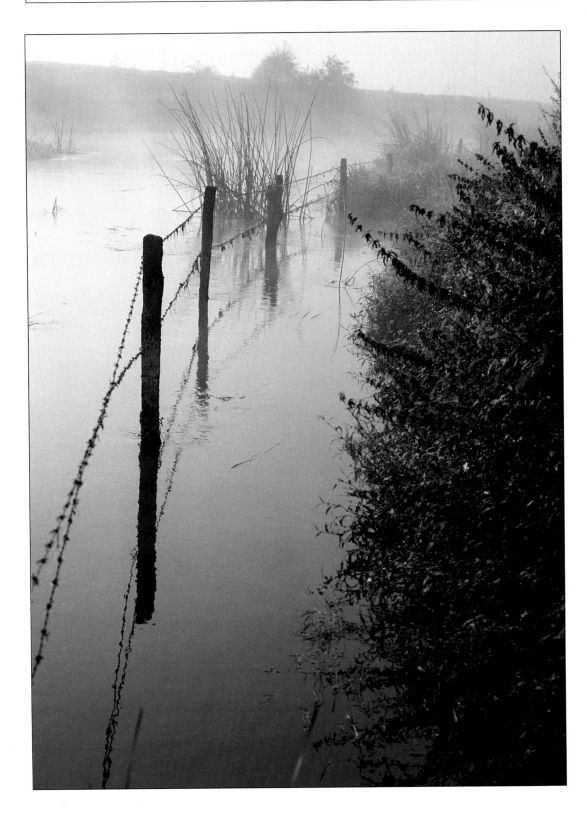

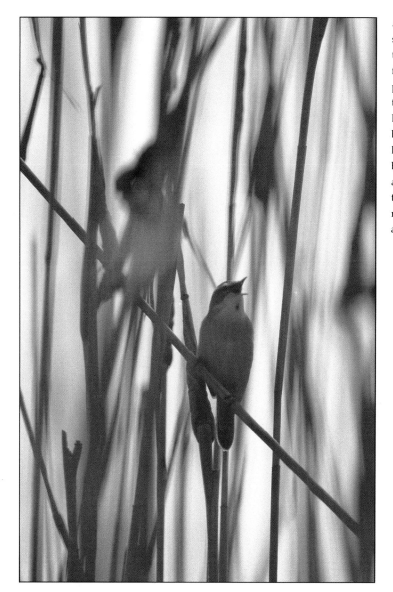

Almost before the day has dawned, a sedge warbler blasts its song through the reeds. Turning its head back-and-fore to spread the song as widely as possible, this little bird declares its territory in an unmistakable fashion. Later in the day, when the mist has been cleared by the sun and colour has returned to the world, insects will be on its menu. Warm days of spring attract mayflies from the water into the reeds, where the sedge warbler need only turn its head to snatch yet another.

A barbed-wire fence fades away into the early morning mist. Erosion has worn away the bank of the river, putting the fence in its course.

123

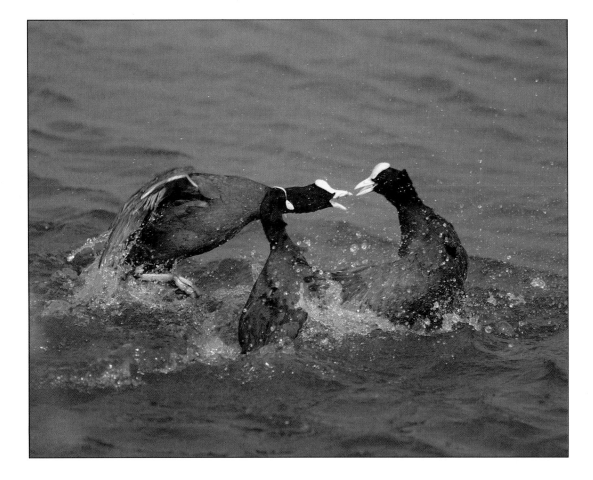

Although during the winter many coots can be seen feeding together in harmony, when the breeding season arrives they become very territorial. Fights often break out (*above*) and the adversaries attempt to duck or drown each other, using their feet as well as their beaks. Nearby, a great crested grebe is sitting on a clutch of eggs within its nest of floating vegetation (*opposite above*). Great crested grebe courtship is long and complicated and extends into the incubation period. However, the commotion caused by the coots, only a few feet from the nest, is of greater concern. Diving underwater, the grebe attacks the coots from beneath, pecking at their feet. It finally splits up the fighting coots with an aggressive display on the surface (*opposite below*) and sends them scuttling in different directions.

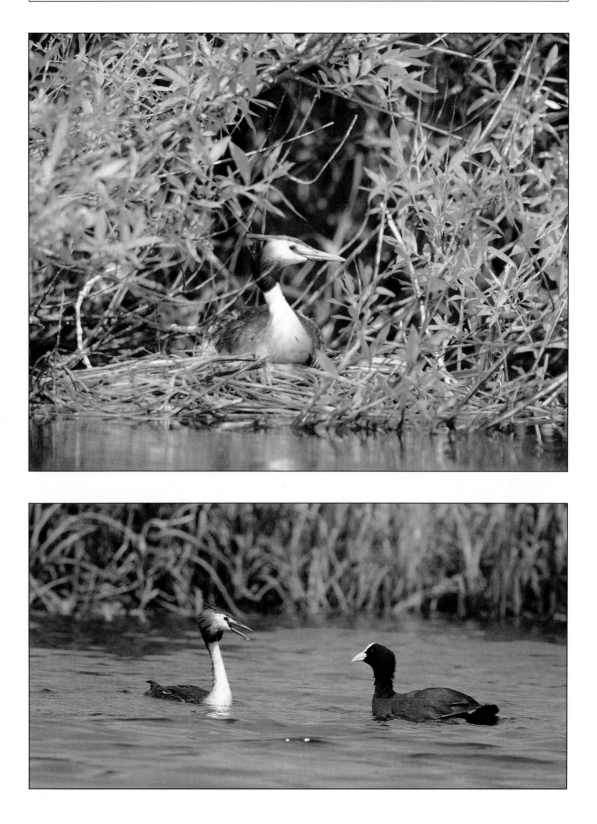

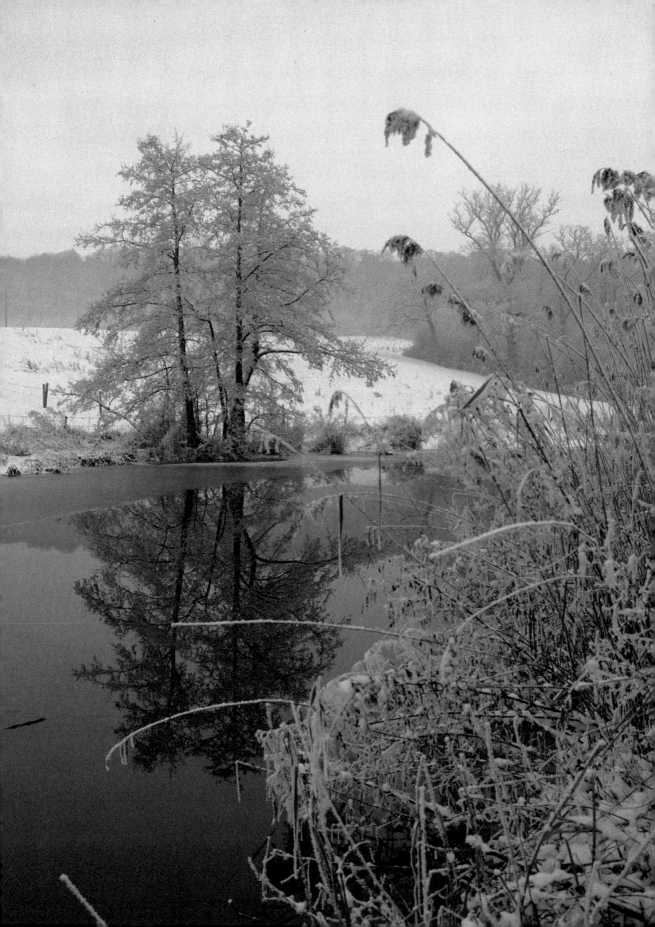

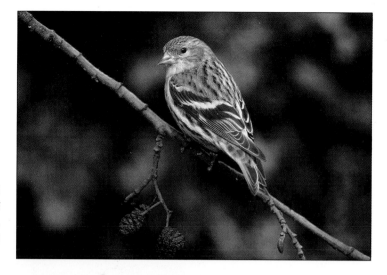

As winter grips the river, frost and snow decorate every twig and leaf with patterns of ice. In hard weather, creatures arrive from far afield to find a little shelter in the river valley.

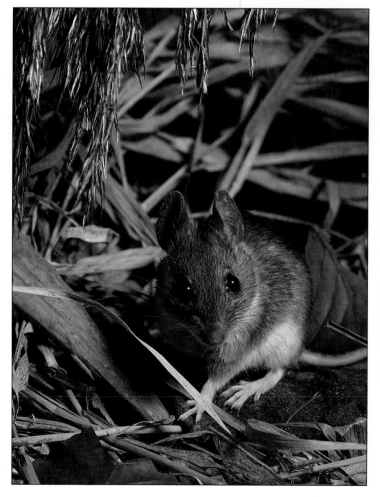

Siskins are small and agile finches that search the trees for seeds. Little groups of birds move along the river valley spending a great deal of time feeding, especially in alder trees. When the warmer days of spring arrive, most siskins will move north to Scotland, where they nest in the tops of conifers.

Within the shelter offered by the reeds, a yellow-necked mouse clambers through the dense vegetation. The reeds provide a multitude of seeds and plenty of dead, dry leaves with which to construct a nest. The yellow-necked mouse is the largest of the British mice, and is the most athletic, able to climb, jump, and run with great power. However, although the river bank may provide a temporary home, the yellow-necked mouse will not swim unless forced to.

No other flower symbolizes spring as clearly as the primrose, whether it appears on a roadside bank, on chalk downland, or beside the river.

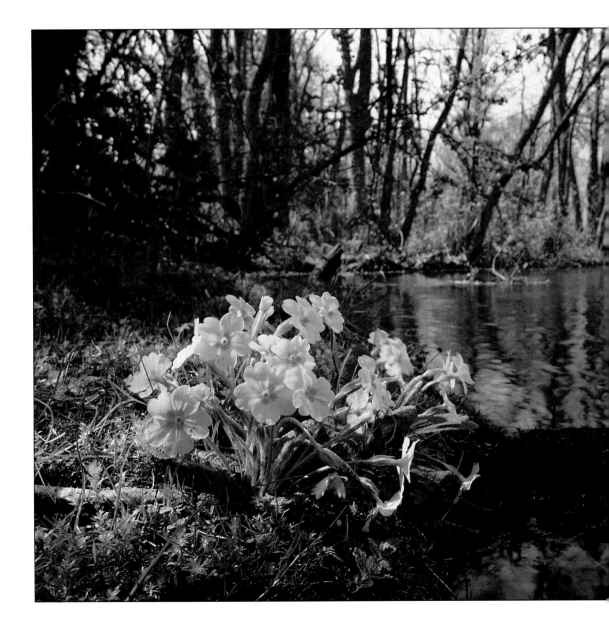

The green-veined white butterfly is often found in areas of marshland close to the river. Because two broods are produced in a season, the butterfly can be found flitting amongst the lush vegetation from May through to August. One of the caterpillars' food plants is lady's smock, which is always found on damp ground.

A young starling enters the water for the first time, to drink in the shallows. During the summer, certain areas of shallow water are very popular with birds that would normally have little to do with the river. The river-bed must be firm and gently sloping to attract them. Nevertheless, some places that seem ideal are never used, whilst others are used constantly.

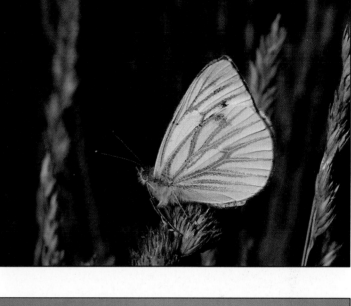

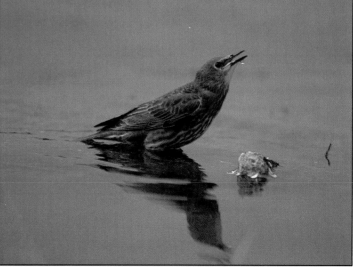

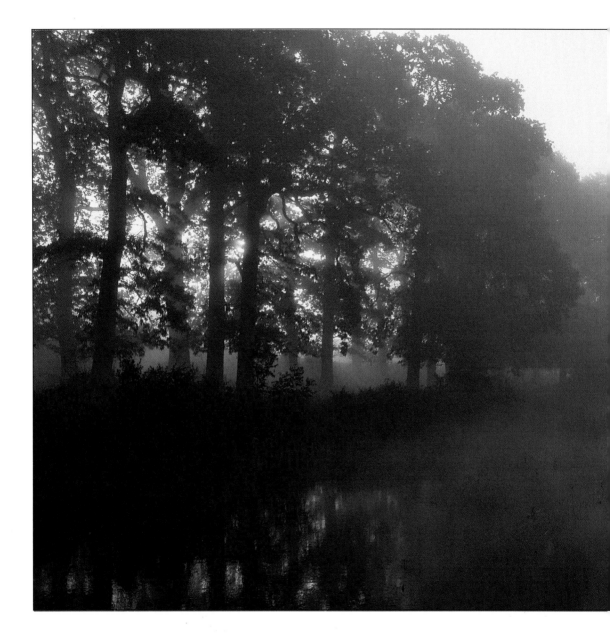

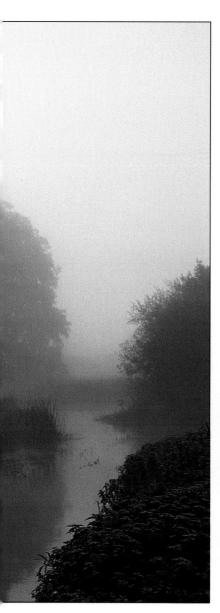

In late summer and autumn, the white fruiting bodies of fungi can be found in the water-meadows. Lawyer's wigs, or shaggy ink cap, are the popular names for this species, and both names are equally descriptive. The fungi appear in the early morning but will not last the day, because they quickly mature and as the day passes they seem to 'melt' from the edges, dripping black fluid.

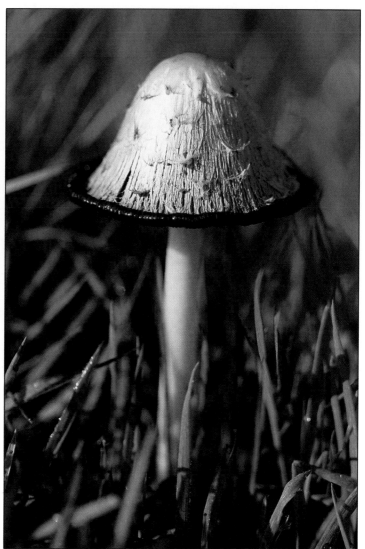

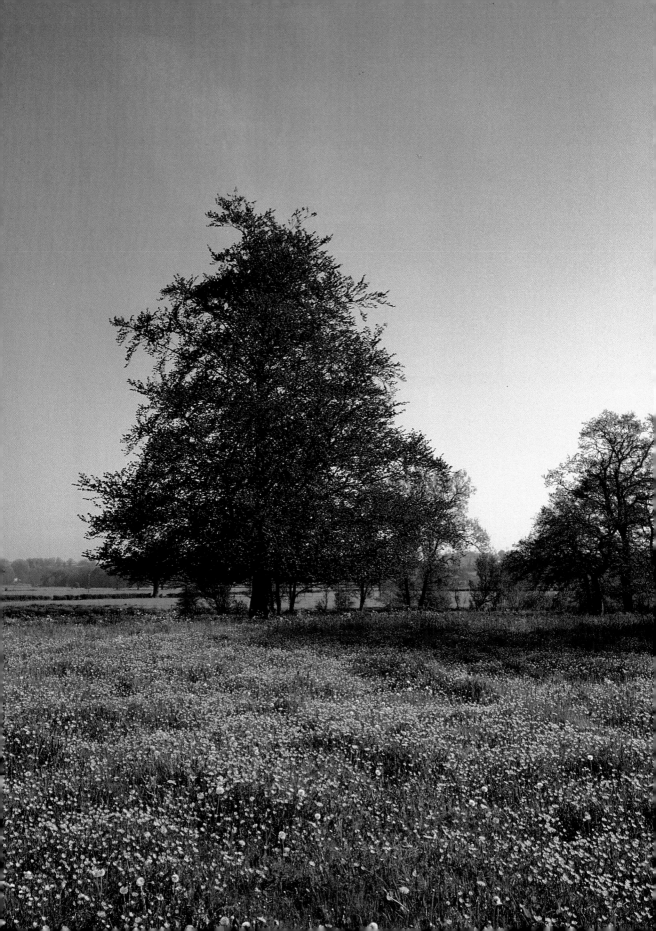

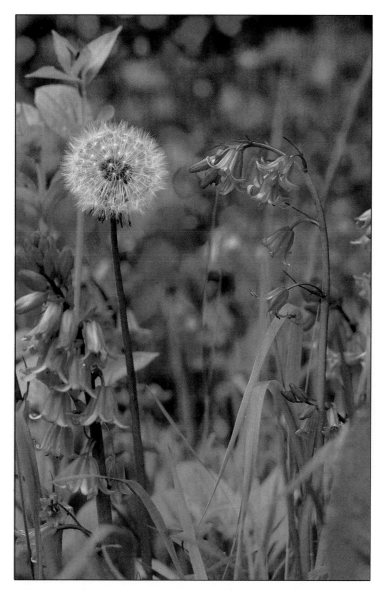

It would take only a breath of wind to spread the seeds of the dandelion across the meadows. But here in a sheltered part of the river bank, nothing stirs. Bluebells also enjoy this sheltered spot. However, when the intense summer sun arrives, the bluebells will need shade from the trees overhead.

Fresh leaves on the copper beech tree, and a field full of buttercups: the water-meadow is seen at its best in early May. Later in the season other wild plants will take the place of the buttercups, but they will be hidden by the grass as it grows taller, ready for a hay crop.

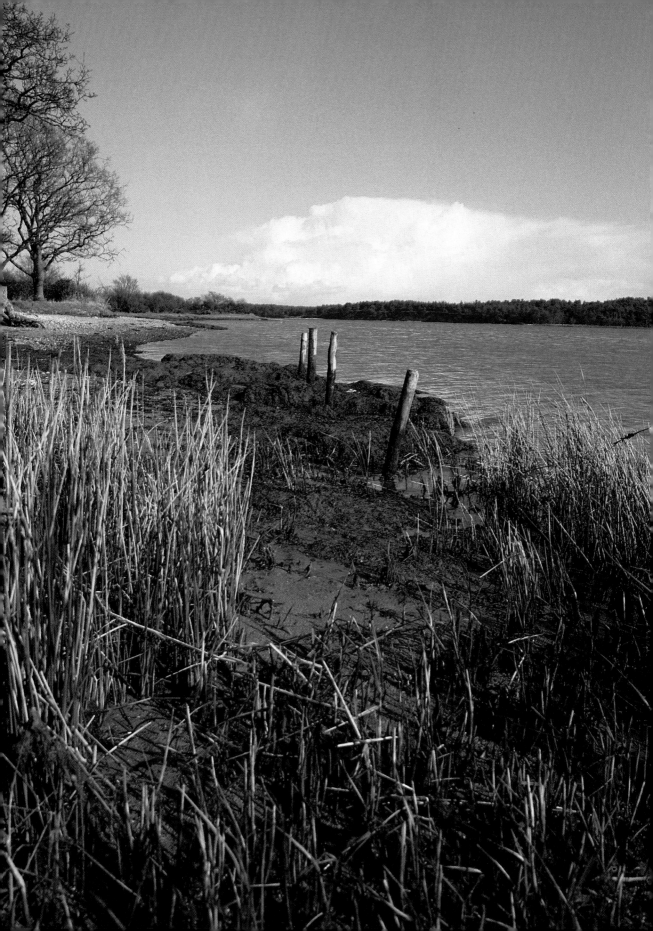

THE
ESTUARY

LIFE WITHIN THE estuary is influenced by two forces that are new to the river: the rhythmic swell of the tide, and the constantly changing salinity. It is the meeting-place of two worlds, the vastness of the ocean and the smaller privacy of the river. Some creatures are happy to drift between these worlds, while others find the changes impossible to live with. A black-headed gull is equally content to ride the saltwater waves as it is to paddle in the freshness of the river. A water-vole, on the other hand, cannot cope with the rise and fall of the tide, nor can frogs spawn in saltwater. Many fish pass through the estuary waters on their journey upriver to spawn. Others live their whole lives in either salt or freshwater – the estuary being an uncrossable barrier.

However, the estuary is more than just a meeting-place. It is an extremely productive environment that provides a permanent home for a multitude of plants and animals. This is well illustrated by the countless thousands of wading birds that feed on the worms, molluscs and crustacea that thrive in the estuary's mud. Many of these small creatures can live only within the estuary environment.

Man has also learned to live with and enjoy the rise and fall of the tide, and many estuaries have become natural harbours containing pleasure boats and huge sea-going vessels. To a naturalist who has explored the river, the estuary is a place of new and exciting possibilities.

When the river arrives at the estuary, its course is virtually complete. It has reached old age, its energy is spent, and much of its drive is lost in the swell of the tide. The little tumbling brook of the high moors and the crashing energy of its youth are left far behind, and the river is in a more expansive mood, brought about by its maturity. Spreading out over the flats, the river slows almost to a standstill. The sweet fresh water mingles with the salty tide and the river is lost forever, its identity fading into the vastness of the ocean's waters. Over countless years, molecules of moisture will evaporate again into the clouds, to fall once more as rain on the highlands.

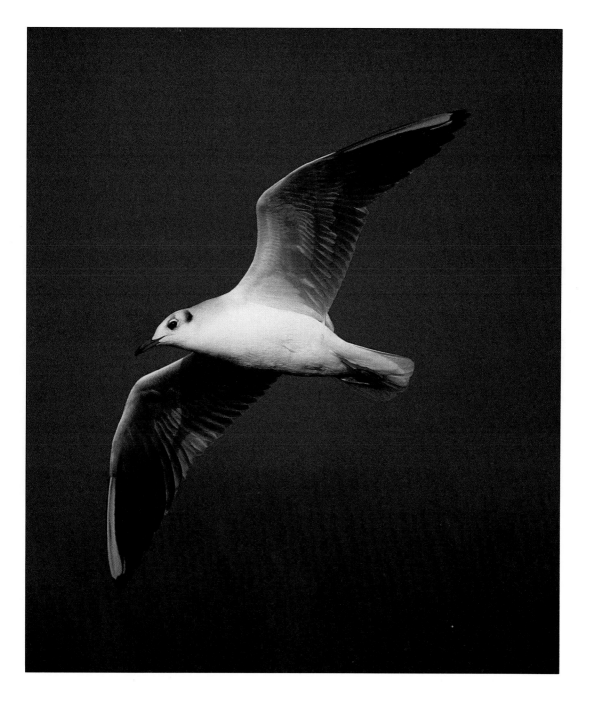

Thunder clouds gather, moving slow-
ly over the reed-beds (*page 135*),
whilst across the darkened sky a
black-headed gull lets out a raucous
scream. Once the breeding season is
over the black-headed gull loses the
colouring on its head, only a patch of
brown remaining behind the eye. As
the wind whips the heavy raindrops
into sheets of falling water, the es-
tuary becomes a bleak and wild place;
a reminder of the moorland where the
river began its life many miles away.

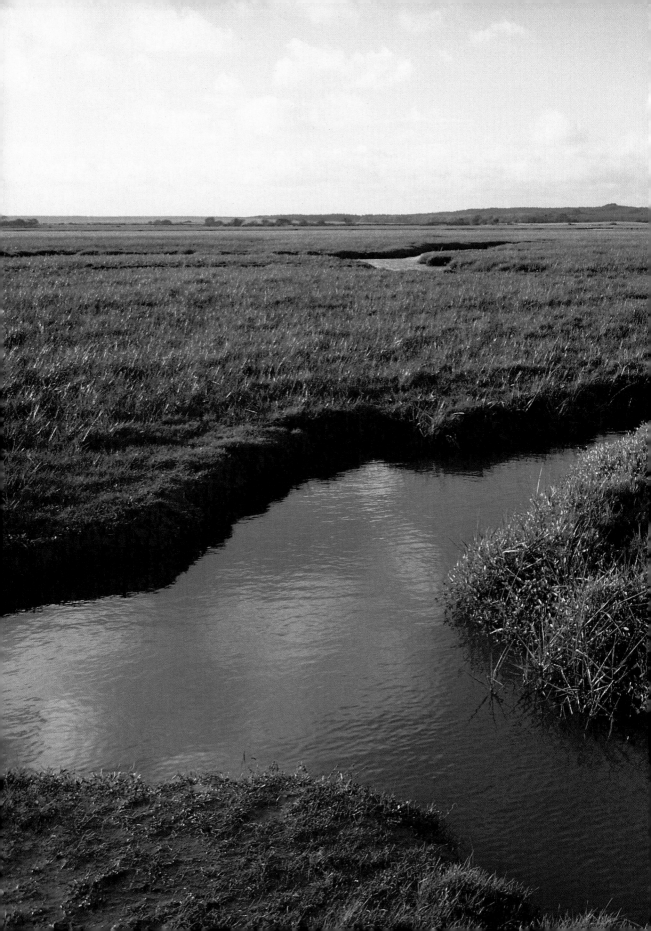

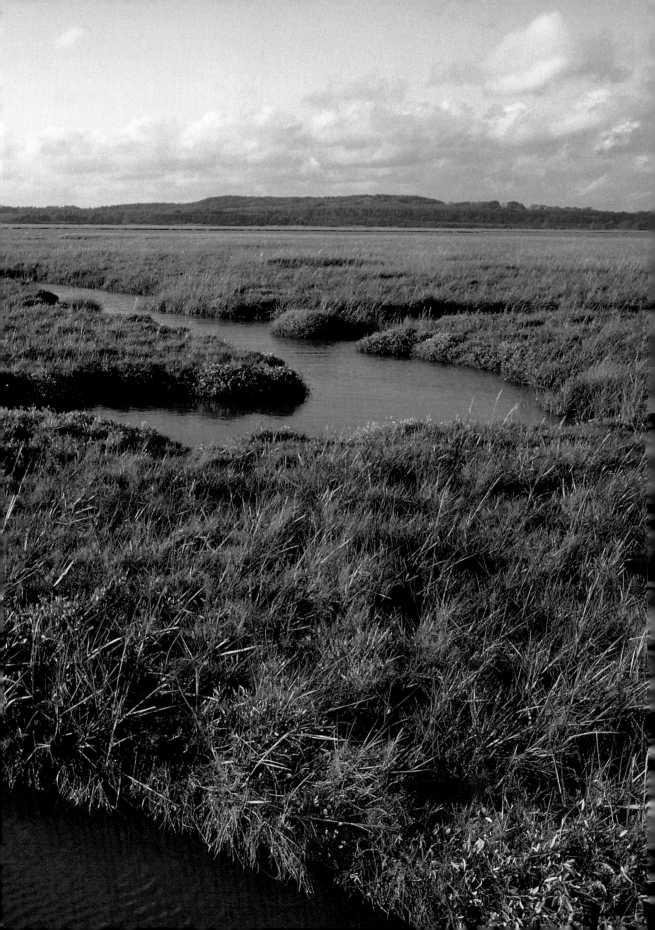

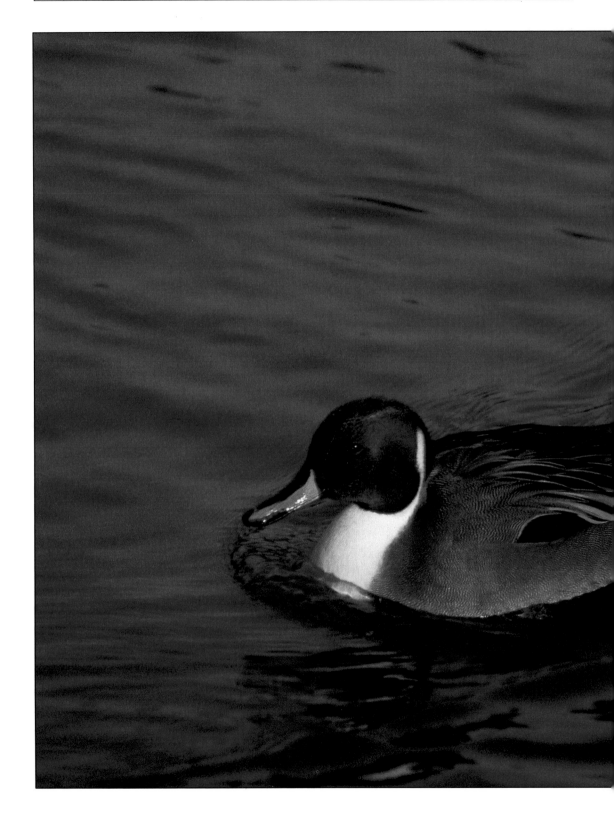

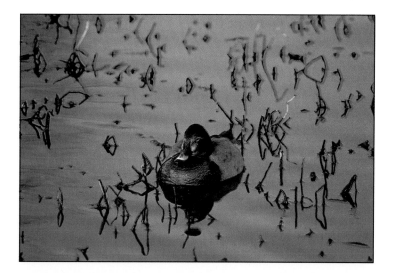

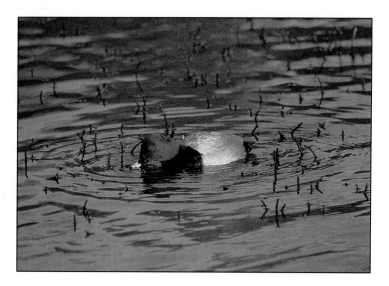

The estuary is a superb gathering ground for a great variety of ducks, and although pintail (*left*) and pochard (*above*) nest in freshwater, hundreds winter and roost in the estuary. The nest is hidden among grassy waterside vegetation and is constructed of broken reeds or grasses and lined with down. As with all wildfowl, the pochard duck (*top*) lacks the distinctive plumage of the drake (*above*). While the male is built to attract the female, she is coloured for camouflage because she alone will incubate the eggs, sitting vulnerably for many days and relying on her cryptic plumage. During the day many ducks rest together on open water, where there is safety in numbers, and all-round visibility. As evening arrives, the pochard will dive beneath the surface to feed on roots, leaves and the seeds of aquatic plants, while the pintail dabbles on the surface or up-ends in shallow water.

The estuary is a meeting-place for the world of the river and the world of the sea; creatures arrive from the fresh-water and from the ocean. An indication of this change in the river is the appearance of shore crabs, which find their way into the estuary from the saltwater and are able to live with the constantly changing salinity.

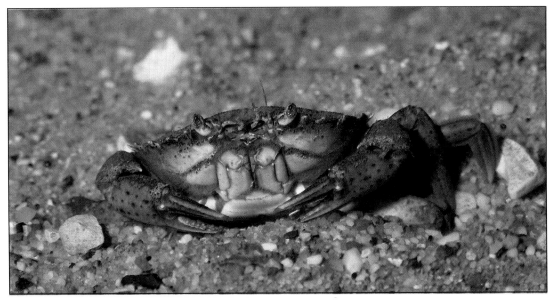

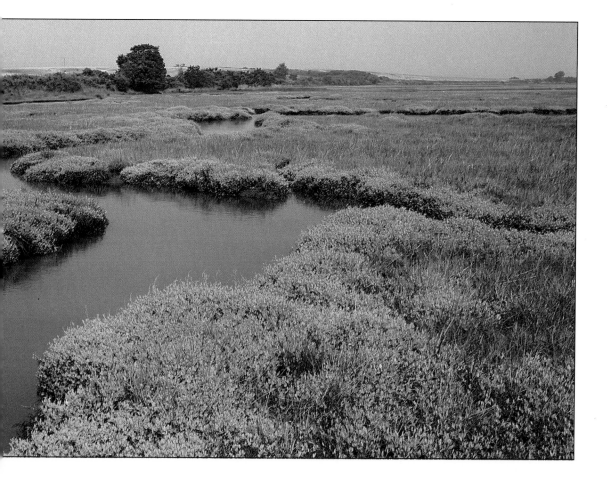

In these areas of salt marshes the carpet of sea purslane becomes established. Having encroached from the marsh edge, it traps more and more silt around its stems and leaves. As the sediment builds up it becomes exposed to the air for longer periods. Other plants become established on it and natural reclamation slowly takes place.

Common terns are annual visitors to the estuary, arriving each year to breed on little islands of shingle and sand. They are beautiful, streamlined birds, delicate and elegant as they fly with grace and ease over the waves of the estuary. They arrive from the South Atlantic in late April and May, and with much excited calling and courtship begin the breeding season. The chicks are fed mainly on sand-eels caught by plunge-diving from a height into the estuary water.

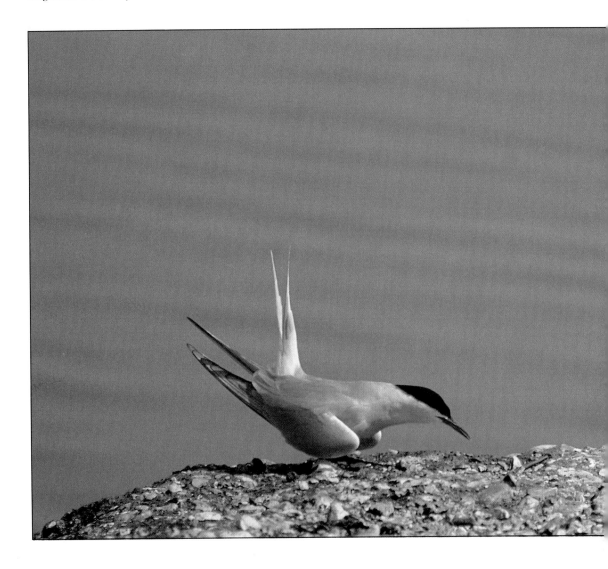

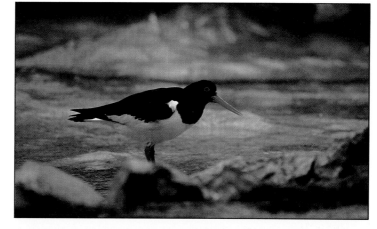

Unlike the tern, the oystercatcher is resident in the British Isles throughout the year, its excited piping calls being heard on many estuaries. It feeds on mussels and cockles, and its bright orange bill is a useful tool for either hammering or stabbing them open.

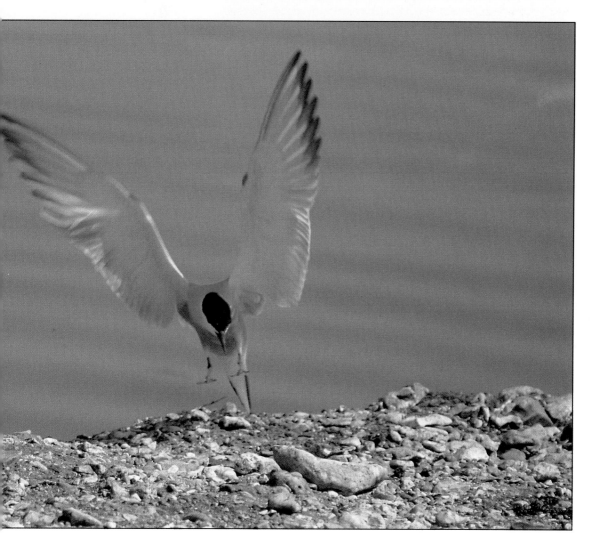

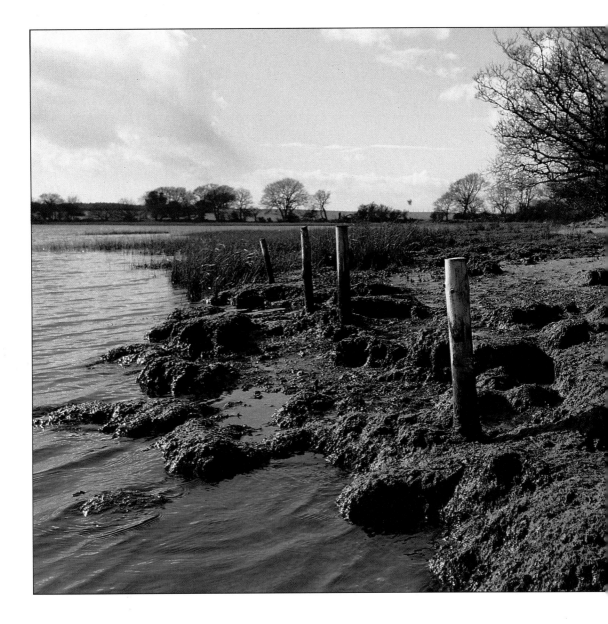

Green algae covers the mud-banks of
the estuary where salt- and fresh-
water meet.

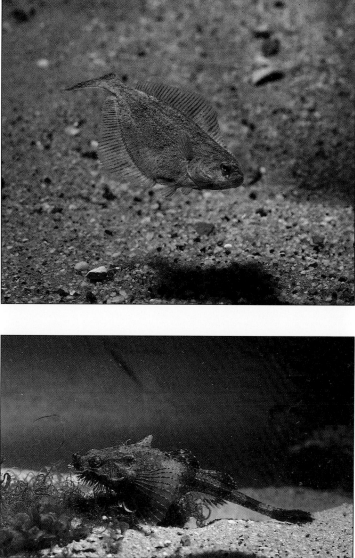

The flounder (*top*) adopts the colour of its surroundings supremely well and is able to bury itself beneath the sand with only a few wriggles of its flat body. Its eyes protrude through the sand, and, as each eye is able to move independently, it has all-round vision. This flat-fish can tolerate nearly fresh water and so can be found a long way upstream on occasions.

One of the strangest fish encountered in the estuary is the pogge (*above*). It is an extremely ugly, bottom-feeding fish that sifts through the mud and sand with the mass of barbels beneath its head. It is completely encased in bony plates that overlap along the length of its body. Although the pogge is not a strong swimmer this is unimportant because, in the estuary, the river current has been lost in the more gentle swell of the tide.

147

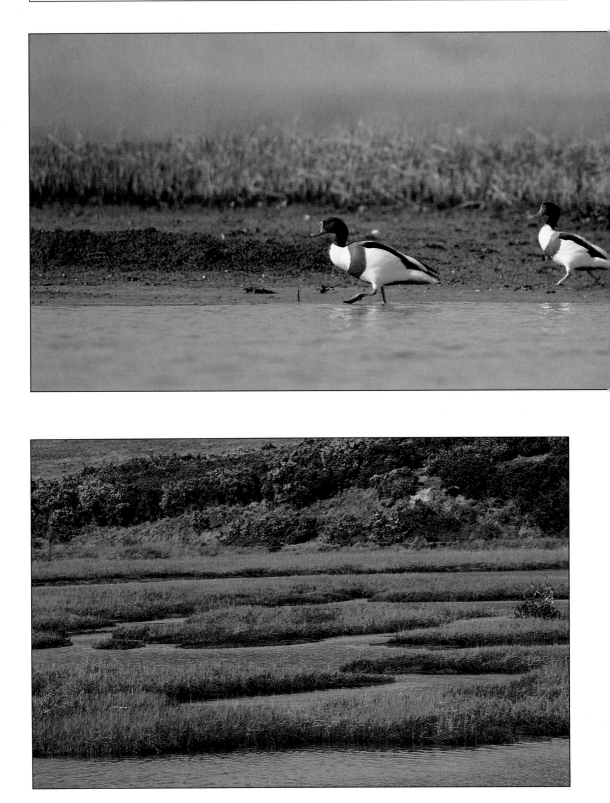

The life of the shelduck revolves almost exclusively around the estuary; it is rarely found on the open sea or on inland waters. Although the shelduck will eat a certain amount of vegetable matter, its diet consists chiefly of molluscs and small crustacea, feeding particularly on the millions of tiny snails that live in the estuary mud. Smaller in size than a typical goose, and larger than a normal duck, the shelduck falls between both families. It nests in burrows in the ground (often rabbit burrows), from where the female will lead her young to the water. Within a few weeks, many shelduck families meet together and form large groups of chicks that may be cared for by only a couple of adults.

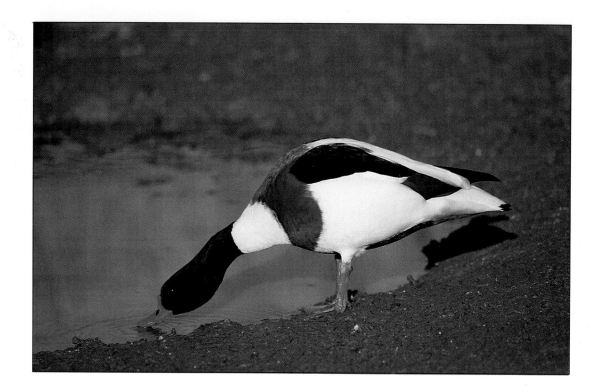

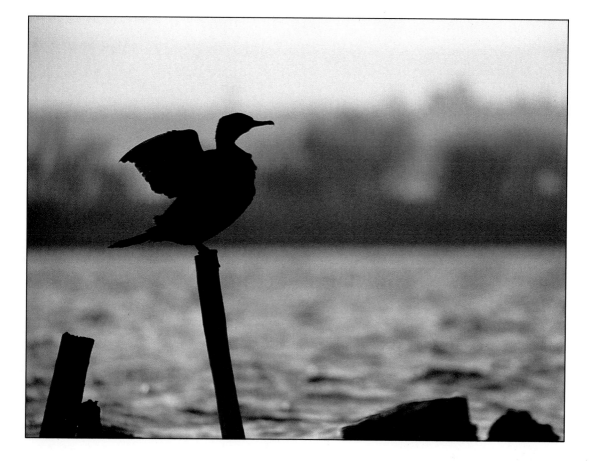

Autumn mist shrouds the estuary and only the closest objects can be seen in detail. The sheet of mud fades away into the distance, and the stillness of the moment is exaggerated by the isolation created by the mist. As the tide rises, water creeps stealthily across the mud and the world seems devoid of life except for the distant call of a redshank.

Through the mist a cormorant can be seen with wings outstretched to dry its plumage. This bird is a superb fisher, feeding on flat-fish from the estuary, along with other types of fish. Beneath the water it holds its wings tightly to its sides as it pursues the quarry, using its powerful, webbed feet to thrust through the water. The cormorant is generally regarded as a sea bird, but many cormorants venture miles inland, especially during the winter months, to feed on fish found in lakes and rivers.

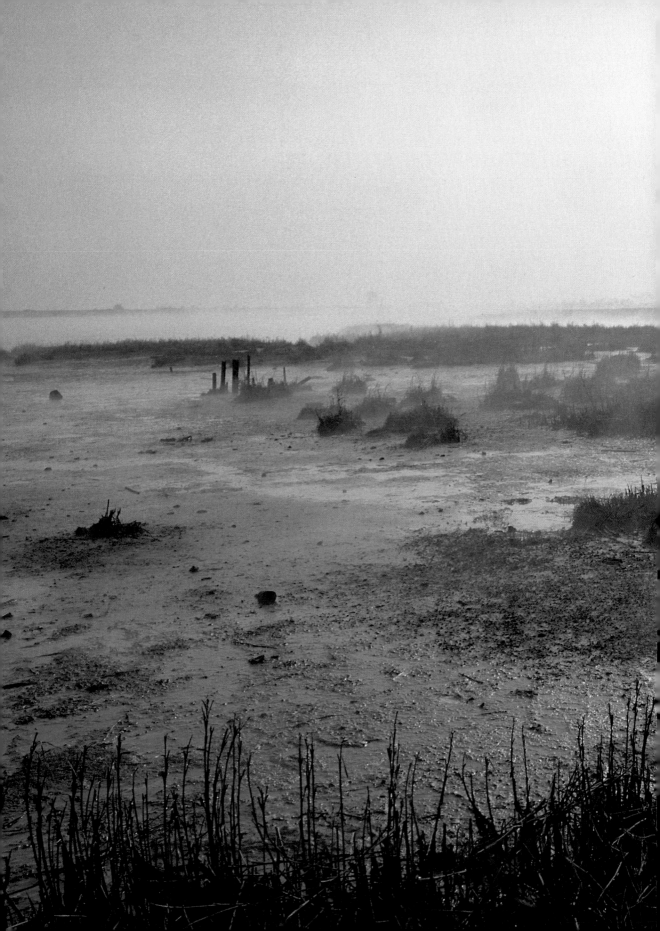

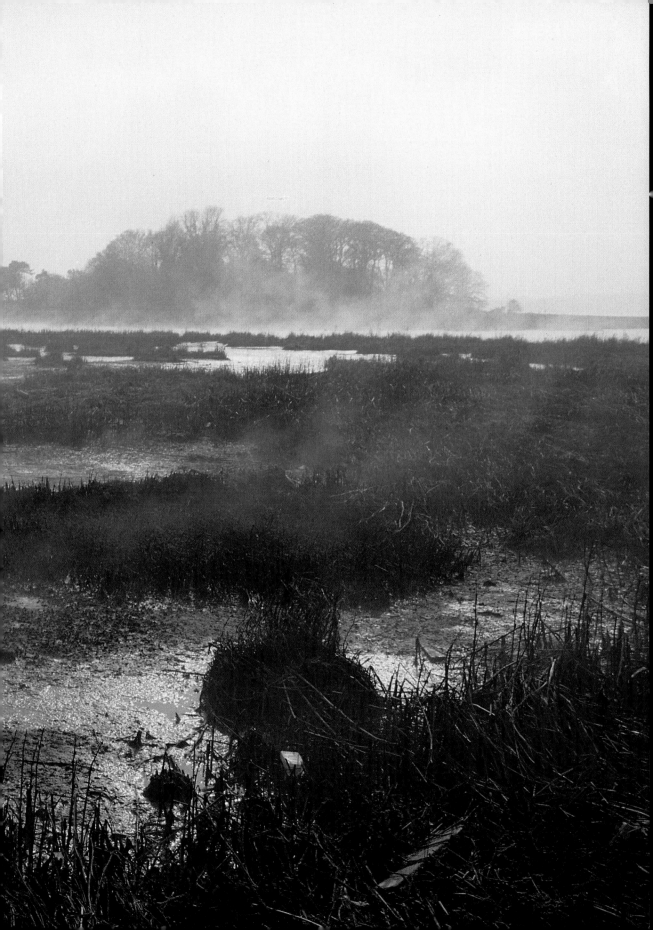

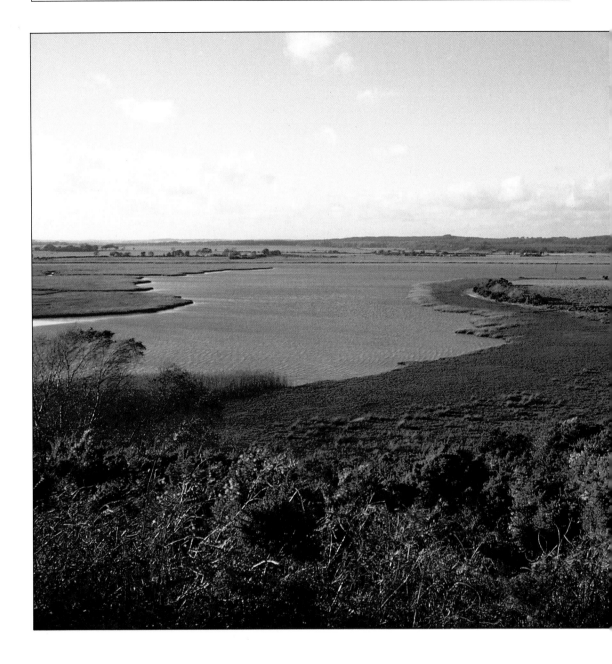

Overlooking the estuary we can clearly see the lazy end of the river. Its energy spent, it meanders across the flats to melt into the ocean. Although the life of the river is drawing to a close, the estuary itself teems with activity. The rich mud is full of crustacea, molluscs and worms that are food for fish and birds alike. In their turn the fish and birds are prey to other birds, and even mammals; the web of life is endless.

The abundant life of the estuary is obvious from the mass of shells cast aside on the beach. It would seem that they were deposited some time ago and became encased in the peaty soil of the bank. Owing to more recent changes in the movement of the estuary waters, the bank has been washed away revealing the old shells, cleaned by the tide and bleached by the sun.

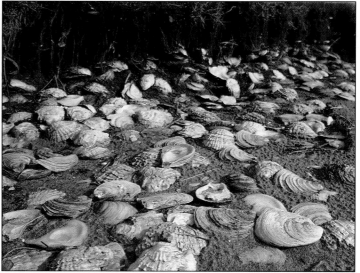

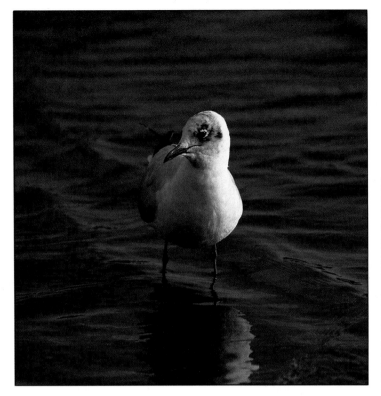

As the sun dips in the sky, a black-headed gull rests in the shallow water. It may have spent the day many miles inland, feeding behind a plough or foraging in a rubbish tip, for it is comparatively unafraid of man. It may roost in the company of hundreds of other gulls, numbers and the openness of the estuary providing security.

A canada goose is silhouetted against the rippling reflections of the setting sun. It can easily be found along any lowland stretch of river, and is at home on lakes and ponds as it is on the estuary. Feeding on nearby grassland, it walks or makes a short flight to suitable grazing, but in towns it has learned the value of crusts of bread from the hands of man. As the goose walks in the sunset, it is a reminder that the estuary brings a tranquil end to the living river.

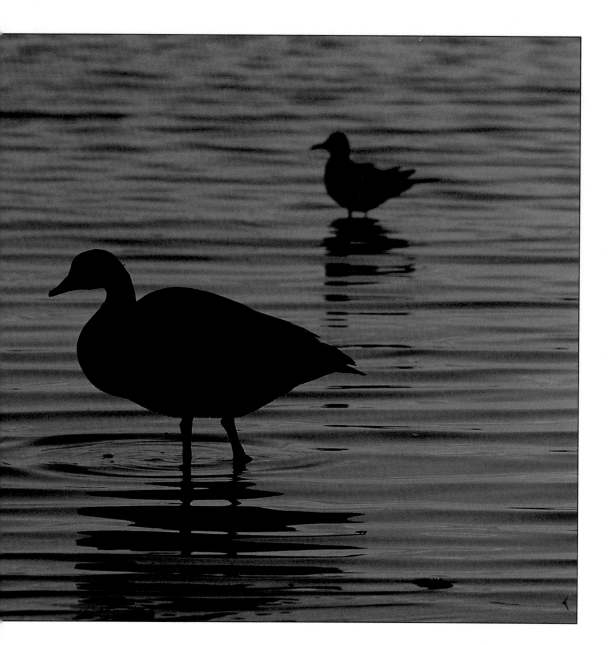

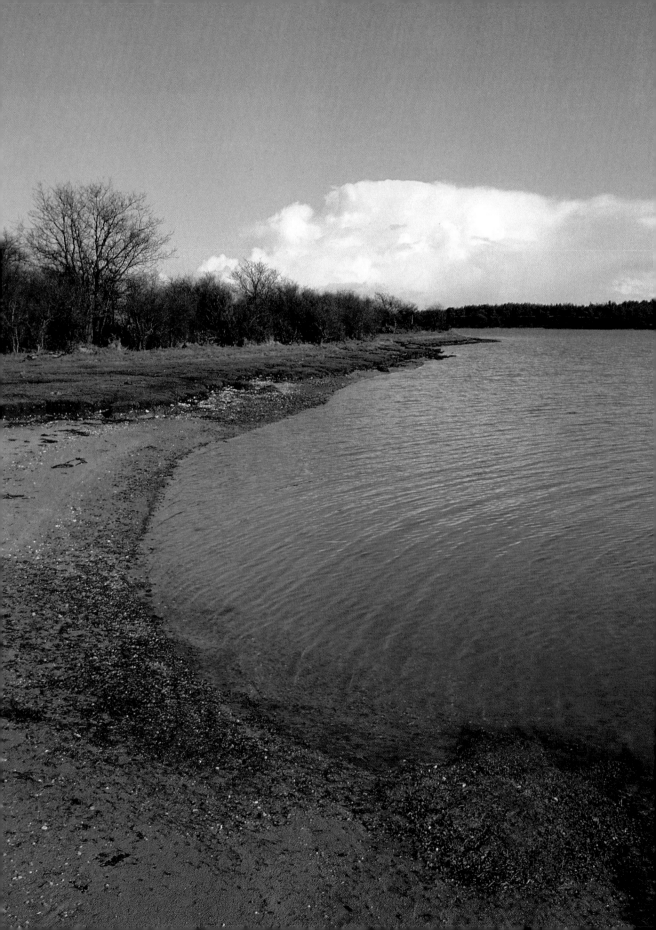

INDEX